GLORIOUS SKY

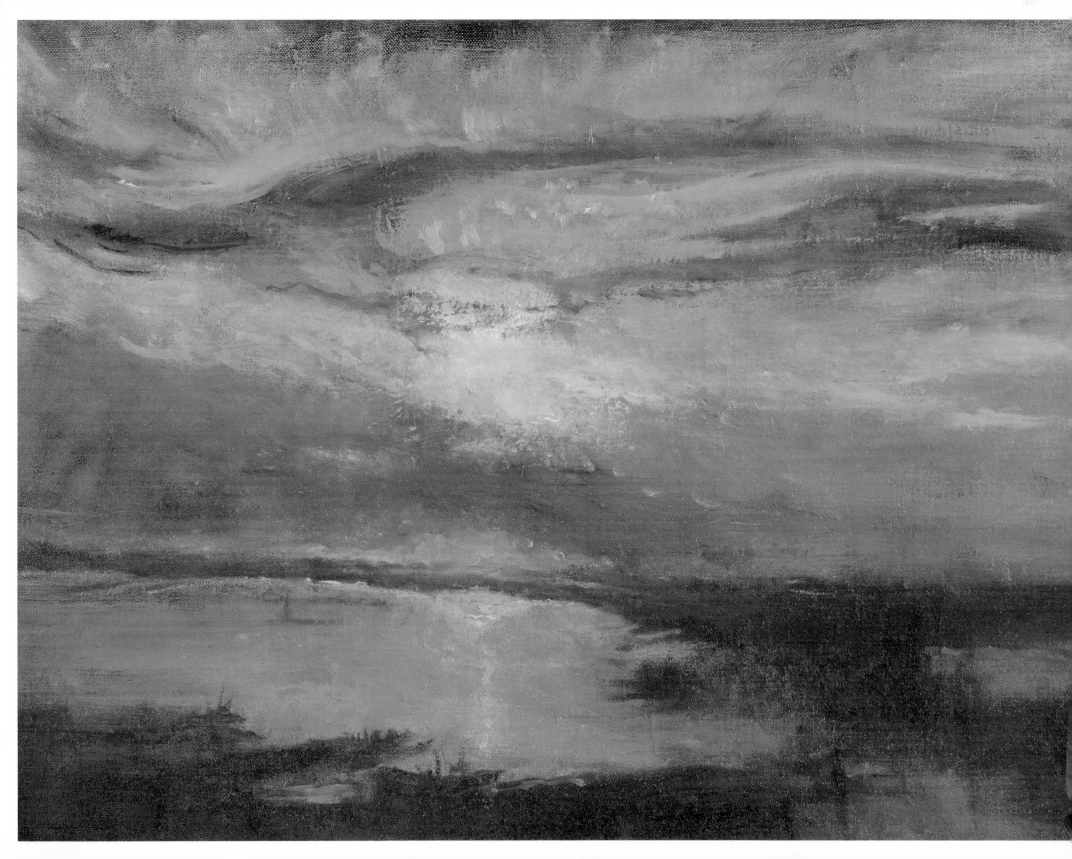

GLORIOUS SKY

HERBERT KATZMAN'S NEW YORK

JULIA BLAUT WITH CONTRIBUTIONS BY ALISON LURIE, KATHERINE E. MANTHORNE, AND JILLIAN E. RUSSO

MUSEUM OF THE CITY OF NEW YORK

IN ASSOCIATION WITH D GILES LIMITED, LONDON

Published on the occasion of the exhibition *Glorious Sky: Herbert Katzman's New York*
Organized by the Museum of the City of New York
November 5, 2010–February 6, 2011

First published in 2010 by Giles
An imprint of D Giles Limited
4 Crescent Stables
139 Upper Richmond Road
London sw15 2TN, UK
gilesltd.com

For the Museum of the City of New York:
Guest Curator and Project Editor:
Julia Blaut
Designer: Laura Howell
Copy Editor: Helena Winston

g

For D Giles Limited:
Produced by Giles, an imprint
of D Giles Limited, London
Proofread by Melissa Larner

Printed and bound in China

Blaut, Julia.
Glorious sky : Herbert Katzman's New York / Julia Blaut ; with contributions by Alison Lurie, Katherine E. Manthorne, and Jillian E. Russo.
p. cm.
Published on the occasion of an exhibition held at the Museum of the City of New York, Nov. 2010–Jan. 2011.
ISBN 978-1-904832-83-6
1. Katzman, Herbert, 1923–2004–Exhibitions. 2. New York (N.Y.)–In art–Exhibitions. I. Katzman, Herbert, 1923–2004. II. Lurie, Alison. III. Manthorne, Katherine. IV. Russo, Jillian E. V. Museum of the City of New York. VI. Title. VII. Title: Herbert Katzman's New York.
N6537.K33B58 2010
759.13–dc22 2010021729

EDITOR'S NOTE

All artworks illustrated in the two plate sections are by Herbert Katzman. Untitled works are followed by parenthetical titles. An italicized title indicates a title that, while not given to the artwork by the artist, has come to be associated with it. An unitalicized title is purely descriptive. Unless otherwise noted, plate captions identify works from left to right across a spread.

FRONT COVER
Herbert Katzman
Untitled (*View of Manhattan*), 1995
(plate 64)

BACK COVER
New York Bay, October 8, 2000
(plate 35)

FRONTISPIECE
Boomerang Cloud, New York Bay, 1999
(detail of plate 33)

CONTENTS

FOREWORD

SUSAN HENSHAW JONES

Ronay Menschel Director of the
Museum of the City of New York

Glorious Sky: Herbert Katzman's New York is the first major museum presentation of the dramatic cityscapes by the Midwestern artist depicting his adopted city. Herbert Katzman's bold harbor sunsets, panoramic vistas of the Hudson and East Rivers, and loving depictions of the city's iconic skyline, bridges, and landmarks reveal not only his distinctive and committed style, but a long-term love affair between the artist and the sweeping, watery world that defines the geography of New York.

Although Katzman first made a name for himself in the New York art world of the 1950s and was chosen as one of the "Fifteen Americans" in the landmark 1952 Museum of Modern Art exhibition of the same name, as his career went on, his representational work was often seen as out of step with his times. As Julia Blaut and Katherine E. Manthorne demonstrate in their essays for this exhibition catalogue, Katzman remained committed to older artistic traditions in an era in which Abstract Expressionism had become the national style. And yet he was, in important ways, part of a quest by an eclectic group of artists working in the city following World War II who were all individually striving to define their own versions of an American artistic vision.

This exhibition and book are made possible by Joanna and Daniel Rose, to whom we are so very grateful. It is rooted in their conviction that Katzman, a friend of theirs for many years, had been largely forgotten as an accomplished artist and that his artistry merited an exhibition. We at the Museum of the City of New York responded not only because Katzman was deserving as an artist, but also because Katzman's was a New York life. Although he was born in Chicago and spent time in Florence, Paris, and the northern suburbs of New York, it was New York City that nurtured his artistic vision. He first came to the city as a young man in 1950, and he made his name in New York galleries and museums. In 1971, he moved into the newly opened downtown Westbeth Artists Housing, a singular attempt by the public and nonprofit sectors to provide artists with housing and studios. New York was Katzman's inspiration and subject matter, compelling him to return to it anew, again and again, to paint it from the same or a slightly different view or perspective.

The hard work of many people made this book and the exhibition that accompanies it possible. Our thanks go first to the Katzman family for sharing the life and work of their father. We are also enormously thankful to the other generous lenders to the exhibition. I am deeply grateful to the guest curator, Julia Blaut, whose dedication and thoughtful insights have helped to show Katzman's work in a new light. Working under the direction of the Museum's Deputy Director and Chief Curator, Sarah M. Henry, she was ably assisted by curatorial assistant Jillian E. Russo and the Museum of the City of New York's own invaluable Susan Gail Johnson. Laura Howell provided the beautiful book design and exhibition graphics, and Ana Luisa Leite created the striking exhibition environment in which a new generation will come to know Herbert Katzman's New York.

ACKNOWLEDGMENTS

JULIA BLAUT
Guest Curator

Glorious Sky: Herbert Katzman's New York was only possible due to the support and encouragement of colleagues, friends, and family—both of the artist and my own. When Sarah M. Henry, Deputy Director and Chief Curator of the Museum of the City of New York, an old friend before a colleague, asked me to curate an exhibition of Herbert Katzman's works for the museum, I welcomed the chance to explore a side of the New York school that has been too often overlooked. I wish to thank Sarah and Susan Henshaw Jones, the Ronay Menschel Director of the Museum of the City of New York, for this opportunity. As a lifelong New Yorker, I could not help but be seduced by Katzman's ethereal views of this great city.

We are indebted to the generosity of our lenders: Ann and Andrew Dintenfass, Drs. Nicole and John Dintenfass; Susan Subtle Dintenfass; Terry Dintenfass, Inc.; Malcolm Holzman; E. William Judson; Alison Lurie; National Academy Museum, New York; Palmer Museum of Art of The Pennsylvania State University, University Park; Daniel and Joanna S. Rose; Mr. and Mrs. David S. Rose; and the Katzman family, as well as those lenders who wish to remain anonymous. It is an honor to have been entrusted with these cherished works.

In researching this exhibition, the members of the *Glorious Sky* team and I have prevailed upon colleagues in libraries, universities, and museums around the country. For their help in answering our numerous questions, I would like to thank: Lynne Addison, Cristin O'Keefe Aptowicz, Julie Barten, Jennifer Belt, Sheelagh Bevan, Ivy Blackman, Hannah Blake, Glenn Bradie, Emily Braun, Jeff Burak, Susan Davidson, Becky Davis, Amy Densford-Giarmo, Charles Denson, Jonathan Derow, Robin Jaffee Frank, Kiowa Hammons, Michelle Harvey, Patricia Hills, Kathy Kienholz, Suyeon Kim, Stacy Kirk, Athena LaTocha, Cheryl Leibold, Erin M. A. Lewis, Jackie Maman, Cara Manes, Leo Mazow, Christa Molinaro, Kira Osti, Jane T. Paul, Marshall Price, Catie Rachel, Carol Rusk, Dyani Scheuerman, Aimee R. Soubier, Lee Stalsworth, Beverly Balger Sutley, Jennifer Tobias, John Vitagliano, Brienne Walsh, Amy Watson, and David Whaples.

Many friends, relatives, and students of Herbert Katzman were enormously generous with their time and with sharing recollections about him: Sheldon Bach, Nicolas Carone, Phil Cates, Jane D'Arista, Todd Groesbeck, Karen Hill, Allison Katzman, James Kearns, Jonah Kinigstein, Marc Kristal, Barbara Kulicke, Matteo Martignoni, Bill Murphy, Don Perlis, Eric Protter, Harry G. Segal, Steve Sherman, Aaron and Nina Tovish, Kristi Ylvisaker, and Sarah Yuster.

The exhibition catalogue is the product of the hard work of many people. I appreciate the perspectives brought to Katzman's art by the essays authored by Alison Lurie and Katherine E. Manthorne. Jillian E. Russo, who served as curatorial assistant for the project, thoughtfully researched and wrote the Chronology and the Exhibition History sections of this volume. My thanks go to Laura Howell of Juicyorange for her inspired design; Ali Elai of Camerarts, New York, who provided the

majority of new photography of Katzman's works; and Helena Winston, who went above and beyond in the care she took in copy editing this volume. My thanks also go to our publisher D Giles Limited; Dan Giles, Managing Director, and Sarah McLaughlin, Production Director, ably coordinated the multiple components involved in bringing us this finished book.

I have been fortunate to have had the opportunity to work with the talented staff at the Museum of the City of New York, including Susan Gail Johnson, Curatorial Associate, who was superb in coordinating innumerable aspects of the exhibition and catalogue. Aditi Halbe and Abby Lepold, Associate Registrars, under the direction of Giacomo Mirabella, Chief Registrar, were invaluable in managing all aspects of the loans and transportation, and for ensuring the safekeeping of the artworks.

The exhibition design is the result of the creative vision of Ana Luisa Leite and benefited from the thoughtful graphic design of Laura Howell and lighting design of Mary Ann Hoag. We are fortunate to have had the guidance of the Museum of the City of New York veterans Kassy Wilson, Exhibitions Coordinator and Eddie José Bartolomei, Chief Preparator.

Above all my thanks go to the artist's children, Nick, Steve, and Annie Katzman, who were completely dedicated to the realization of this exhibition and the accompanying catalogue. Over the last year and a half, they tirelessly responded to queries, shared stories, and made their father's artworks and archives fully available to us. Their commitment to Katzman's legacy has been an inspiration.

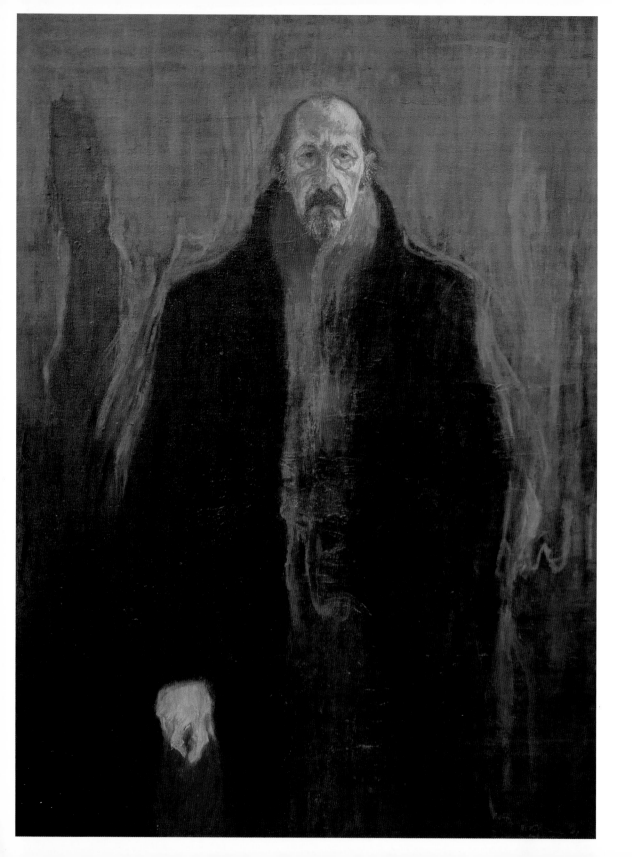

REMEMBERING
HERBERT KATZMAN

ALISON LURIE

Herbert Katzman
Self-Portrait in Multicolored Scarf, 1987
Oil on canvas
49 ¼ x 36 ¼ inches (126.4 x 93.3 cm)
Drs. Nicole and John Dintenfass

Herby Katzman did not look like an artist. He seemed, rather, like some guy who had come to paint the house or build a shed. He wore old, rumpled work clothes and his basic mood was one of meditative melancholy, broken now and then by pleasure in the company of people he cared for, or a rush of joy at the sight of a sudden slant of green light over a clouded, gray sea, or a child in a lion mask. "Hey, look at that!" he would cry, staring and smiling.

Though Herby titled one of his paintings of himself *Portrait of a Grouch at 65* (1988), in conversation he was friendly and animated, but sometimes sardonic, especially about contemporaries who had heaved themselves onto the bandwagon of prevailing popular styles. He was, and remained, an expressionist. Over time, abstraction, Pop art, Minimalism, Color Field painting, graffiti, and performance art passed him by, horns blaring. As a result, he became unfashionable, supported by a few discerning collectors and by teaching jobs. Meanwhile his work got better and better.

I first got to know Herby well in the 1960s, when his family and mine both began to spend summers on Martha's Vineyard. Herby and his beautiful wife Duny usually rented a big, old house near Lambert's Cove. It was full of battered Victorian antiques; skinny, long-legged children; and animals—dogs, cats, turtles, fish, lizards, and birds. It was also full of Herby's paintings, which I saw there for the first time. I was amazed by their energy and confidence, and above all by their sense of movement, change, and flux. In family portraits, his three children and his wife sometimes seem about to leap up and dance, and his landscapes are often in motion, like an image on the Weather Channel, all rushing dark clouds, storms, and gusts of brilliant sun.

Like one of his (and my) favorite artists, George Inness, Herby was a visionary painter whose canvases often seem to be dissolving into light, transforming into water, cloud, mist, iron, stone, flesh, and then back. His portrait drawings, on the other hand, are silent and searching, exploring the inner nature of his subjects, including himself.

For over 50 years, Herby lived and painted in New York—after 1971 in a studio in Westbeth Artists Housing, where the Hudson River and the Statue of Liberty were visible from his windows. I often stopped to see him when I was at Westbeth, where my sister and her family also lived. He would make me a cup of tea, tell me news of his children, and show me what he was working on. At first, the apartment was half home and half studio, but as time passed, the art took over and Herby's living quarters were reduced to a bed in one corner.

Some of Herby's greatest and most moving pictures were of the city, especially of New York Bay, the East River, and the Brooklyn Bridge, in every kind of light and weather—they were for him what haystacks had been for Monet. At times he worked from photographs, many of them taken by his daughter Annie. In the end, I think of him as one of the victims of the World Trade Center attacks, which he could see from his studio window. The dust from the explosion entered his lungs and worsened the asthma and emphysema that led to his death three years later. When I went to see him in those last years, he breathed with difficulty, and his voice was rasping and rough. But though he could no longer use oils, charcoal, or pastels, he did not give up art: his last striking views of the city were done from memory and in pencil.

HERBERT KATZMAN AND THE MUSEUM OF MODERN ART'S *FIFTEEN AMERICANS*

FIGURATION AND ABSTRACTION, NEW YORK

IN THE 1950s

JULIA BLAUT

Herbert Katzman
Brooklyn Bridge, 1951–52
Oil on canvas
54 x 60 inches (137.2 x 152.4 cm)
Collection of the Katzman family

Upon viewing the much-anticipated exhibition *Fifteen Americans* at The Museum of Modern Art in June of 1952, one of the preeminent Bauhaus masters, Lyonel Feininger, wrote to the exhibition curator, Dorothy C. Miller:

> After leaving you at the entrance to "15 Americans" . . . I went through a remarkable experience. In the first place, we soon understood the reason you had put so much "heart" into the exhibition, for it is a very strong collection, and beautifully arranged on the broad, high wall surfaces. And increasingly "wild," as you called it. . . . After having left [Jackson] Pollock, the effect of the first rooms seemed to decrease, until we found the works original indeed, but [no] longer "wild." Especially [Herbert] Katzman?—I found superb in his two river scenes, especially his "Brooklyn Bridge" [p. 12 and plate 1]. I must have been exceptionally impressed, with something of "awe" at the pure power of his "representation"—which was abstract as nature can be translated into, by sheer energy. [William] Baziotes also is very much to my liking, although here abstraction in his paintings means almost the opposite of Katzman's.[1]

Herbert Katzman? Who was this unknown artist who had been included in the then most prestigious exhibition of contemporary American art in the United States? Certainly there was no more celebrated venue for an emerging artist in the early 1950s than New York's Museum of Modern Art. *Fifteen Americans* was the third in a series of six shows conceived by the museum's director, Alfred H. Barr, Jr., and organized by Miller, the museum's Curator of Museum Collections. The so-called *Americans* exhibitions spanned the period between 1942 and 1963, during which time New York was transformed from a provincial outpost to the epicenter of the international art world.[2] The *Americans* exhibitions were considered the most exciting and controversial contemporary art shows in New York, and inclusion in one bestowed "near-divine judgment"[3] upon a handpicked group of artists. At the age of 29, Katzman was one of only five figurative painters included in an exhibition that has become most famous for introducing Abstract Expressionism to a large New York audience.

The great variety of art practiced in the New York art world in the early 1950s has, until recently, gone unacknowledged in most accounts of this period.[4] Indeed, little is remembered about the arts during this decade other than the emergence of the Abstract Expressionists, whose avant-garde status brought New York after World War II to the center of the Western art world for the first time. The accomplishments of artists who worked in a figurative mode have been almost entirely forgotten. In fact, the art community that Katzman found on his arrival to New York in August of 1950, after having spent several years in Paris (1947–50), was self-consciously inclusive of different styles. Freedom to choose a mode of artistic expression was embraced as fundamental to the freedom of living in a democratic society and resulted in a plurality that was in direct contrast to the uniformity of the art produced under totalitarian regimes. As a young artist returning stateside and committed to painting in a representational style, Katzman could not have received a grander welcome into the New York art world.

Katzman had been an exceptional student at the School of the Art Institute of Chicago, from which he graduated in 1946.[5] The school remained essentially conservative, favoring an American

regionalist style and offering students a classical fine-art education with heavy doses of life drawing, anatomy, and art history. However, Katzman's most important teacher, Boris Anisfeld, instilled in him an appreciation of modernist painting, especially German and French Expressionism. From these earlier movements, Katzman incorporated into his works the use of bold, simple shapes, often outlined in black, and a nonreferential, daring use of color. He shared with the Expressionists the desire to show the visible world through the lens of his own emotional response to it; looking to nature, but extracting its most essential qualities and depicting it with animated brushstrokes and distorted forms. It is certainly this aspect of his work to which Feininger, who had been associated with the German Expressionist groups Die Brücke (The Bridge) and Der Blaue Reiter (The Blue Rider), must have responded upon seeing Katzman's river paintings in *Fifteen Americans*. Katzman's *Brooklyn Bridge* (1951–52, plate 1) and his painting *The Seine* (1949, fig. 1) displayed these expressionist qualities but with a focus, which he also shared with Feininger, on majestic, urban structures. *The Seine* was among the few works bought by the museum at the close of the *Fifteen Americans* exhibition—an event that was in and of itself a great honor.

After graduation, Katzman had left Chicago for Paris, the city that, in the late 1940s, was still a hub of modern art. He had been awarded the John Quincy Adams Foreign Traveling Fellowship by the institute. Combined with support from the GI Bill, for which he was eligible due to his service in the Navy, he was able to stay in Paris for three and a half years. While living there, Katzman absorbed firsthand the lessons of European modernism, developing a hybrid style that combined a grounding in representations of place with abstracted forms and brushwork. The expatriate circle of artists with whom he associated was an eclectic group. His art-school classmate, Joan Mitchell, lived downstairs from him; she was still working in a representational mode and had not yet arrived at the abstract style for which she later became known.

FIG. 1
Herbert Katzman
The Seine, 1949
Oil on canvas
37 ¼ x 63 inches (94.6 x 160 cm)
The Museum of Modern Art, New York,
Gift of Mr. and Mrs. Hugo Kastor

Katzman exhibited at Galerie Huit, a cooperative gallery whose artists worked freely in diverse styles, abstract or representational. Figurative painters such as Katzman and Jonah Kinigstein showed side by side with Sam Francis and Al Held, both of whose art already verged on pure abstraction.[6]

The painting that Katzman considered to be his strongest work from his European sojourn was *The Seine*. Although he painted it in Paris, it was not done *en plein air*, but later, in his studio, from drawings and notes that he had made on-site. According to Katzman, "When viewing the painting one is standing on Pont Neuf looking toward Pont St. Micheal [*sic*]." He wanted to capture the essence of the place: "Paris in the wintertime is grey and bleak and one never really feels warm. Everybody looks like they will never dry out, inhabitants and city alike—but the place has great beauty. This is the feeling I wanted in the painting."[7] Using primarily a palette knife, Katzman rendered the river in a lurid green, which flows between the tilting gray buildings of the old city.

His *Notre Dame* (1951, fig. 2) is also of a subject that dates back to his time in France. The cathedral had been visible across the river from Katzman's Paris apartment at 73, rue Galande. Painting

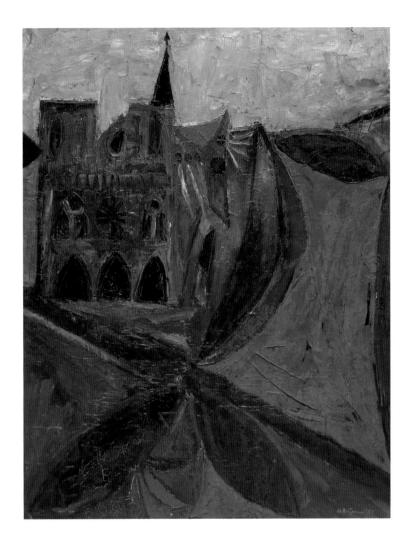

While Katzman was in Paris, many artists in New York were also absorbing the lessons of modernist art. The city had been energized by the many prominent European avant-garde artists who had lived there during the war and by the permanent collection and temporary exhibitions of European modernism at The Museum of Modern Art. The cross-fertilization of cultures and techniques enriched the city's artistic environment, much as the Paris art world had been stimulated by the influx of foreign artists earlier in the century.[10] During this period, both formal and informal art collectives in New York supported diversity in art-making practices. The Hofmann School was a case in point. Hans Hofmann, a German-born, Paris-trained artist, became one of the most renowned teachers in the city after the war. While his students received traditional training, they also became well versed in the history of European modernism and went on to work independently in a wide range of styles.[11]

Simultaneously, a backlash was developing against modern art and particularly abstraction. The press, the government, and even President Harry Truman labeled abstract art as subversive or "Communistic."[12] The artists who would come to be known as the Abstract Expressionists had not previously viewed themselves as a collective with a shared artistic agenda. Yet as abstraction came under attack, critics, if not the artists themselves, began to view them as an entity identified as the "New York School" of abstract painters who worked primarily in two modes: gestural or color field.[13] Of the critics supporting abstract art, Clement Greenberg, came to the fore in the late 1940s as its most highly vocal defender. In his 1954 essay "Abstract, Representational, and so forth," Greenberg maintained that the major art of the period broke with the art of the past and that while representational art was more immediately likeable, the best art of the period was nonfigurative.[14] In his essay "'American-Type' Painting," published the following year, he noted that "'abstract expressionism' . . . [was] the first manifestation of American art to draw a standing protest at home

FIG. 2
Herbert Katzman
Notre Dame, 1951
Oil on linen
45 ⅝ x 35 inches (106 x 89 cm)
Hirshhorn Museum and Sculpture
Garden, Smithsonian Institution,
Washington, D.C., Gift of Joseph H.
Hirshhorn, 1966

it on his return to New York, he used muted tones of gray (one critic called it "somberly expressionist")[8] with areas of brilliant color—the verdant green of the Seine and two brightly painted boats: one aquamarine and the other red. The distorted shapes and active brushwork are reminiscent of the French Expressionist Chaim Soutine and the coloring of the Fauve painter André Derain—the two artists whom Katzman most admired.[9]

as well as serious attention from Europe."[15] For the first time, Greenberg asserted, the United States could boast of a modernist style that had developed on home territory.

Barr, in his role as director of The Museum of Modern Art, supported abstract art, but not to the exclusion of other styles. Under his direction, the museum's exhibition program was pluralistic. Maintaining that "modern art is almost as varied and complex as modern life," he did not fully subscribe to Greenberg's notion that all contemporary art had to be avant-garde, and he found the work of artists whose styles were rooted in tradition to be praiseworthy as well. Having experienced the negative consequences of censorship in Europe firsthand, Barr argued strongly against any form of partisanship or exclusion in the arts.[16]

Soon after Katzman arrived in New York in 1950, his profile rose, in no small part due to Edith Halpert's eye and contacts. Katzman had been in New York less than two years when Miller discovered him at Halpert's prestigious Downtown Gallery, which had moved to Manhattan's tony Upper East Side. The gallery was well established, having opened a quarter of a century earlier, in 1926, and having championed previous generations of modern American artists, including Stuart Davis, Jacob Lawrence, Georgia O'Keeffe, Ben Shahn, and Charles Sheeler. Halpert was drawn to expressionism in general, and especially that of Katzman.[17] She gave him his first opportunity to exhibit in New York by showing his painting *View of Prague* (1948, fig. 3) in her group exhibition *Newcomers: First Showing of a New Generation* in May of 1951. One reviewer compared it to the work of the Viennese Expressionist Oskar Kokoschka,[18] while another called it one of the two "best paintings in the show . . . big but magnificently handled."[19]

When *View of Prague* was included in the same year in the *60th Annual American Exhibition: Paintings and Sculpture* at The Art Institute of Chicago, *The New York Times* reporter Aline B. Louchheim described the painting in highly emotive terms congruent with the painting's subject and heavily applied red paint:

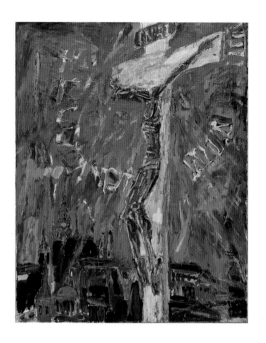

There is a controlled violence about the way the paint is laid on that reinforces the mood of the picture. Above the [r]ooftops of the city of Prague, in the sky—perhaps the universe—above it is a poignant, barely emergent Crucifix. In color all is deep red, red as the blood that has engulfed the world. Outrage and hope, anger and faith are met to create an image which communicates in wholly visual . . . terms.[20]

Characteristic of Katzman, the painting was not done during his trip to Prague in 1946, but two years later, and was based on a sketch of a crucifix, drawn while he was there.[21] The painting conveys what must have been the intensity of Katzman's experience in the old European city, as a Jew after the war. The sense of displacement and isolation in the postwar era was an experience that many of the Abstract Expressionists (some of whom were European immigrants) would have shared with Katzman and also conveyed in their paintings, although in purely abstract terms.[22]

The 60th Chicago Annual had been selected by the museum's director, Daniel Catton Rich, and two curators, Katherine Kuh (whom Katzman knew from his student days, when she had

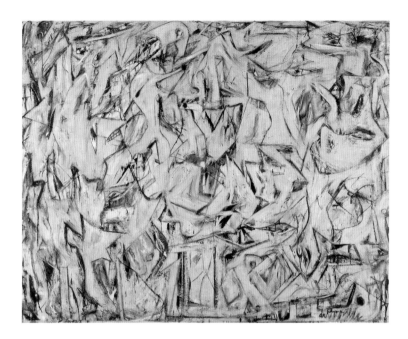

FIG. 4
Willem de Kooning
Excavation, 1950
Oil on canvas
81 x 100 ¼ inches (205.7 x 254.6 cm)
The Art Institute of Chicago, Mr. and
Mrs. Frank G. Logan Purchase Prize Fund;
restricted gifts of Edgar J. Kaufmann, Jr.
and Mr. and Mrs. Noah Goldowsky, Jr.

validity of the paintings has nothing whatsoever to do with the style in which each was painted or with the specific vision which in each case moved the artist." She acknowledged that "there is unfortunately a growing tendency . . . toward bigoted partisanship [in the art world]. . . . Why is it impossible to respect De Kooning *and* Shahn?" In other words, why weren't the abstract, avant-garde paintings of de Kooning and the realism of Shahn regarded as equally valid artistic expressions? Louchheim concluded by commending the Chicago Annual for being "discrimination free,"[26] a fact best illustrated by its evenhanded distribution of prizes.

Following his success in Chicago, Halpert hailed Katzman in the March 1952 issue of *Life* magazine as one of the most promising artists of his generation (fig. 5). The article, "New Crop of Painting Protégés," described how she had arrived at her choices of whom to represent. She had undertaken "a cross-country tour, looked at thousands of paintings, [and] finally came up with nine young artists" whom she showcased in her new ground-floor gallery in 1951. Halpert was serious in rallying behind these artists, buying "out-right from each . . . a minimum of $1000 worth of paintings and install[ing] them in a special room where they [would] be continuously on display."[27] She promoted Katzman among prominent collectors as well as curators from all over the country. The modern-art collector Joseph Hirshhorn was among Katzman's first patrons, having immediately purchased *Notre Dame* from the March 1952 *Recent Arrivals: Downtown Gallery* exhibition. In June, after a visit to Halpert's gallery, the director of Pittsburgh's Carnegie Institute, Gordon Washburn, invited Katzman's painting *The Bath* (1952) to the Pittsburgh International.[28]

It was at this formative moment that Miller first encountered Katzman's work. On January 18, 1952, she contacted him by letter: "I saw your new paintings at the Downtown Gallery yesterday and think the *Brooklyn Bridge* is a beauty." She continued: "I want to invite you to be in an American group show to be held here at the Museum."[29] Five days later Katzman accepted Miller's invitation

opened the first modernist gallery in Chicago) and Frederick A. Sweet. From a group of 178 painters included in the exhibition, first prize went to Willem de Kooning for *Excavation* (1950, fig. 4) and second prize to Katzman for *View of Prague*. It was characteristic of the show that two sides of expressionism, one abstract and the other representational, were celebrated. Indicative of Midwestern skepticism toward contemporary art was the fact that when *Excavation* was offered to the museum as a gift, it was nearly declined at the behest of the trustees.[23] *Chicago Daily Tribune* reviewer Eleanor Jewett wrote that the exhibition "illustrate[s] one or another extreme form of modern extravaganza," and described it as "faddy and temporal."[24] Similarly, *The Art Digest* reviewer C. J. Bulliet described it as "explosive" and acknowledged that "the public resents what it feels as [the] 'snootiness'" of abstract art.[25] Louchheim, however, recognized that "the show seems to prove that . . . this is . . . an increasingly good" period in visual art. She validated the stylistic diversity and admonished her New York readership that "what seems to me most interesting is that the

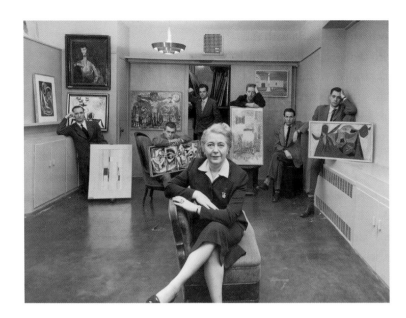

While she acknowledged that "their achievement may indicate trends in our art today . . . the primary intention behind the exhibition . . . [is] to give each artist an opportunity to speak to the Museum's public, in clear and individual terms, through a strong presentation of his work."[34] Included were eleven painters, three sculptors, and "the master of 'lumia,'" Thomas Wilfred, whose art was made "using a light-generating instrument."[35]

Remarking that "American art is rich in diversity," Miller listed the fifteen artists, from those—like Edwin Dickinson, Katzman, and Herman Rose—whose work reflected "experience and its expression . . . related to the world the artist sees about him" to those, including Pollock, Mark Rothko, and Clyfford Still, whose works "fall within the category usually called abstract, which, as many competent observers have remarked, is the dominant trend in mid-century American painting."[36] The figurative paintings were by far more familiar to The Museum of Modern Art's audience. Miller intentionally used these artists' works to strike a balance with the less familiar abstract art, providing something to which all viewers could relate. She arranged the rooms of the abstract artists to start "with a Baziotes piece and then [work] up to a crescendo of Still and Rothko . . . and going into abstract sculpture from there."[37] In the room dedicated to Pollock, a single painting occupied each substantial wall and, as described in Feininger's letter, was generally perceived by the public as "wild" (figs. 6 and 7).

The work of the first-generation Abstract Expressionist painters (Baziotes, Pollock, Rothko, Still, and Bradley Walker Tomlin), as well as that of the sculptors associated with the movement (Herbert Ferber and Richard Lippold), was already known to patrons who frequented commercial art galleries in the late 1940s and early 1950s, but was entirely new to The Museum of Modern Art's general audience. For example, Baziotes, whom Feininger had also singled out in his letter to Miller, had already been embraced by the New York Surrealists in the early 1940s due to his organic forms and fantastic subjects. By

FIG. 5
Edith Halpert and some of the Downtown Gallery's artists, *Life* magazine, March 17, 1952. Seated behind Halpert, from left to right: Charles Oscar, Robert Knipschild, Jonah Kinigstein, Wallace Reiss, Carroll Cloar, and Herbert Katzman Photo: Louis Faurer

informing her: "I was . . . glad that you liked *Brooklyn Bridge* as I feel it's the best thing I've done."[30] In short order, *Brooklyn Bridge* was installed outside of Barr's office, arguably the most prestigious wall space in the museum.[31] More remarkable was the fact that Katzman was among the few artists in *Fifteen Americans* who had not yet had a solo gallery show.

Katzman was represented in Miller's exhibition by six paintings: four cityscapes of Florence, London, New York, and Paris respectively (including the two river paintings), one figure study, and one still life. The show followed the same format that Miller had used in the earlier *Americans* exhibitions. In her foreword to the exhibition catalogue, she wrote that her purpose was "to present the work of a limited number of artists, devoting considerable space, in some instances a whole gallery, to the work of each one."[32] The exhibition also served to expose and encourage the sale of the artists' works to other museums and collectors.[33] The fifteen artists she chose for this *Americans* exhibition were "a group . . . marked [by] individuality and widely differing aims."

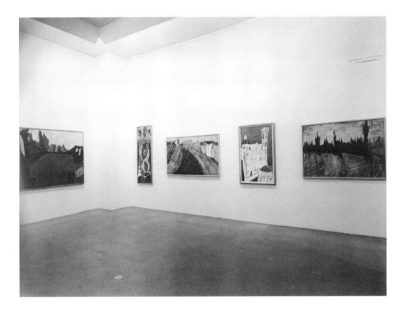

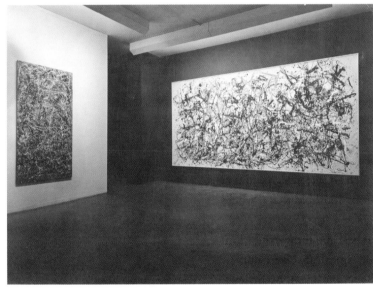

Greek, and the next with the anxiety of a Van Gogh. Either of these emotions, and any in between, is valid to me."[38] By 1947, Pollock had abandoned easel painting and conventional painting techniques in favor of his signature, large-scale, "all-over," poured or "drip" paintings. For a critic like Greenberg, Pollock's canvases were the ultimate in modernist painting and were evidence that progress in modern art had shifted from the School of Paris (which Greenberg considered stalled at Cubism) to painters like Pollock, who were moving away from representation to ever greater degrees of abstraction.[39] Pollock himself maintained that "the modern artist . . . is . . . expressing an inner world."[40] Similarly, Rothko, who only reluctantly gave up figurative painting in 1947, contended that the subject in his color-field paintings was a human one and that he was "finding a pictorial equivalent for man's new knowledge and consciousness of his more complex inner self."[41] Despite the use of an abstract idiom, the Abstract Expressionists' emphasis on an art that revealed the inner life was not so far apart from the European Expressionists who tried to portray a similar subject—albeit through representational means.

The immense scale of the abstract paintings in the exhibition may well have overwhelmed the work by the figurative painters,[42] but the presence of the figurative work was crucial to the message the museum meant to convey. While abstraction might have been coming to the fore, other modes of expression were equally valid. Interestingly, with no sense of a conflict of interest, Elaine de Kooning, the wife of the highly influential Abstract Expressionist and a painter and critic in her own right, championed the inclusion of the work of figurative painter Dickinson in *Fifteen Americans*. Dickinson (like Katzman, a graduate of the School of the Art Institute of Chicago) showed representational yet mysterious landscapes and portraits that de Kooning, in her *Art News* review, described as having "a piercing, nightmarish clarity that recalls passages in Poe." She defended his artistic contribution, which although not avant-garde, was entirely individual: "In a country

FIGS. 6, 7
Installation view: *Fifteen Americans*, The Museum of Modern Art, New York, April 9–July 27, 1952. Works by Katzman, left to right: *Brooklyn Bridge* (1951–52), *Horse Butcher* (1949), *The Seine* (1949), *Giotto's Tower* (1949), and *Houses of Parliament* (1948)

Installation view: *Fifteen Americans*. Works by Jackson Pollock

1950, his canvases had increased in size and his brushwork had become more gestural, but emotion remained a primary subject for him. As he wrote for the *Fifteen Americans* catalogue: "Today it's possible to paint one canvas with the calmness of an ancient

that places a premium on uniqueness of expression, the lack of recognition of such spectacular and original artists is rather astonishing." She continued:

> The rebellion, as manifested in [Dickinson's] art is directed against the rabid rejection—which is the moral basis of much avant-garde art—of a whole area of past tradition. Dickinson stubbornly resists this pressure to reject.[43]

For his part, Katzman's artist's statement, printed in the catalogue, acknowledged his commitment to painting the city, buildings, and people that struck him with their visual power—to paint them as they appeared to him, in a directly emotional manner that expressed his feelings:

> I paint things around me that I like and if at times the paintings move it's because I am moved by the world around me—in that sense I suppose I am an expressionist painter. I do not paint abstractly because if I give up the appearance of the world I find I am unable to become involved in it. I am not interested in its abstract or metaphysical aspects as the subject itself means very much to me. I like the way the yellow-black sky looks over the Brooklyn Bridge, the way the sun hits a building, or the way my wife looks in an ochre-green dress. These are the important things to me and they are wonderful to paint.[44]

The critical response to *Fifteen Americans* was revealing in that it clarified the still-controversial status of modernist art, be it figurative or abstract. While Feininger's letter was not the only laudatory response that Miller received for *Fifteen Americans* (she received support from some progressive art world insiders as well as from the museum's trustees[45]), the exhibition was neither well received by the press nor by much of the public. An abstract painting by Still was vandalized; a faithful patron withdrew his museum membership, indicating that the mix of media and styles "gave . . . a feeling of real depravity" and was potentially "corrupting the taste and standards of the next generation;" and another visitor wrote a scathing letter, to which Miller replied, defending her selection: "advanced forms of art have often been accused of being 'childish.'"[46] The museum purchased just four works from the exhibition, their choices demonstrating their evenhandedness: two abstract paintings (an Edward Corbett and a Rothko) and

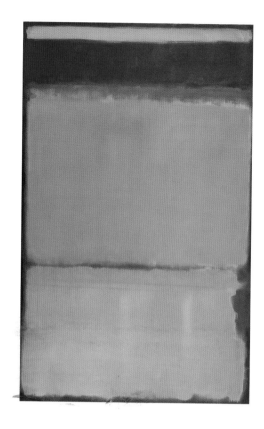

two representational works (a Dickinson and Katzman's *The Seine*). Nonetheless, the purchase of Rothko's *No. 10* (1950, fig. 8), which Barr had selected personally in 1951, caused one member of his acquisition's committee to resign.[47] Such an action signaled that abstract art had not yet gained the strong foothold that it would come to have.

While the press was ambivalent at best about the exhibition, The Museum of Modern Art's "Fifteen Americans" were not ignored. As A. L. Chanin put it in the opening line of his review for New York newspaper *The Compass*: "Once again the Museum of Modern Art demonstrates that it cannot be charged with either lack of courage or conviction." While the show "may well bring laughter and even anger from many visitors, and praise from a few," he wrote, "as a result of this stylistic clash and clang, visitors

will be . . . jolted, or perhaps . . . inspired to think about art in new 'terms.'"[48] The conservative critic Emily Genauer, writing for the *New York Herald Tribune*, appreciated the figurative artists Dickinson, Katzman, and Rose, but found it "difficult to accept the enormous panoramas of emptiness contributed by men like Clyfford Still and Mark Rothko, or the tangled skein-of-wool of Jackson Pollock," and dismissed most of it as "avant-chic."[49] Inversely, Thomas B. Hess, writing for *Art News*, accused the museum of being late in bringing Abstract Expressionism into its galleries: "its timing misses by a few years. . . . The edge is gone, the start, shock, jolt, turn of surprise, instant of disorientation or whatever gave edge and bite have vanished. We say: 'Yes, Jackson Pollock . . . and it's about time he got here, too.'"[50] Equally problematic was the direct affront that Robert M. Coates, writing for *The New Yorker*, levied against the museum for its "capriciousness." He saw the show as "a reflection of a rather supercilious attitude the Museum has shown before toward contemporary American art."[51]

Barr worked tirelessly to defend the museum on all fronts, aiming to find an equilibrium in the museum's programming that he described as neither too progressive nor too conservative with regard to contemporary art, and he avoided playing favorites to European or American modernism. In a letter to the disgruntled museum member who visited *Fifteen Americans*, James Thrall Soby, at the time the interim director of the museum's Department of Painting and Sculpture, volunteered to represent the museum, explaining: "We feel it is our job to show the public the leading tendencies in contemporary art, not to try to tell artists what these tendencies *should* be. . . . An institution such as ours . . . should not try to be censor, reformer or polemic agent, but primarily a barometer to record for the public the prevailing currents."[52] In the first of a series of lengthy letters written while on vacation in Sicily, Barr spelled out for Coates the museum's long record of American exhibitions, observing that whereas The Metropolitan Museum of Art and Whitney Museum of American Art were

amassing collections of only *American* 20th-century art, The Museum of Modern Art had an obligation to cover a wide range. Barr declared that "for me *15 Americans* is the most exciting and dramatic show of American art I have ever seen," and concluded with a bold and prophetic statement: "I myself think that except for a few aged giants in France our country now leads the world in the art of painting."[53]

The Museum of Modern Art was not the only museum in New York to take note of Katzman. The Whitney Museum of American Art would include Katzman regularly in its annual exhibitions of contemporary painting from 1951 through 1957. Since its founding in 1930, the Whitney had traditionally supported realist art. Its acquisitions policy posited "a broad and unprejudiced point of view toward all styles and tendencies; recognition of the new and experimental; willingness to meet the artist on his own terms." The contemporary works that were acquired during the 1950s, however, favored representation; even those that were fundamentally abstract included mostly figures or landscape elements.[54]

Katzman's *Two Nudes before Japanese Screen* (1952, fig. 9), which had been in Halpert's exhibition *Recent Arrivals* in March of 1952, was selected for the Whitney's Annual that year, and it entered the museum's permanent collection in 1953. Soon after the Annual closed, the painting was included in the Pennsylvania Academy of Fine Arts's *One Hundred and Forty-eighth Annual Exhibition of Painting and Sculpture*. Once again, Katzman's painting was selected from a large group, this time from more than 400 entries, as a prizewinner. The jury for painting included fellow Downtown Gallery artist and American modernist Davis and the magic-realist painter Peter Blume. Katzman's painting was heralded as a "sensation"[55] and commended for its "high . . . color and [for being] vigorously expressionist in manner."[56] When the work returned to New York, it was hung prominently in the Whitney's opening exhibition at its new building on West 54th Street, and it was one of the very few works reproduced in *The New York Times* of that major cultural event.[57]

The early 1950s continued as a period of enormous success for Katzman. In 1954, *Art in America* conducted the first in a series of annual polls to "present to the public a sampling of the many talented young or relatively unpublicized painters and sculptors working in various parts of the country."[58] The selection panel consisted of Whitney curator John I. H. Baur, as well as Museum of Modern Art curators Miller and Soby. *Art in America* chose 27 artists from the names submitted by the panelists, of which only six came from the east coast. Nationwide, all the artists selected used an abstract idiom, except for four: Grace Hartigan, Katzman, David Park, and Robert Vickrey—representational painters who "were neither naturalist, Regionalist, nor Social Realist; [for them] 'place' was not geographically but psychologically located."[59]

Nineteen fifty-four also brought Katzman his first solo exhibition at The Alan Gallery in New York. Charles Alan had worked for Halpert before starting his own gallery on East 65th Street the previous year. Having by now established a following, Katzman's one-person debut was another critical success. A *New York Herald Tribune* reviewer observed the features that were outstanding in his work: "reliance in subject matter on forms of the visible world, his expressionist view in his subject's interpretation and his peculiar force as a colorist." While the review acknowledged a debt to Fauvist coloring, it also noted that Katzman had a "considerable essence of his own—vitality, intensity and a rich enthusiasm for painting, as bold as it is brooding and sensuous."[60] *The New Yorker* reviewer Coates observed that "certain influences are still visible in his work," namely Henri Matisse, Amedeo Modigliani, and Pablo Picasso—these "serve only as a starting point for Katzman's inspiration and once off on his own he shows a compositional power and a strength of imagery that are truly remarkable."[61] S. Lane Faison, Jr., writing for *The Nation,* labeled Katzman "a colorist . . . both brilliant and refined" and predicted that "some day, I suppose, this will all turn out to be the early style of Herbert Katzmann [*sic*]. I shall be much interested to watch what evolves as the decades go by."[62]

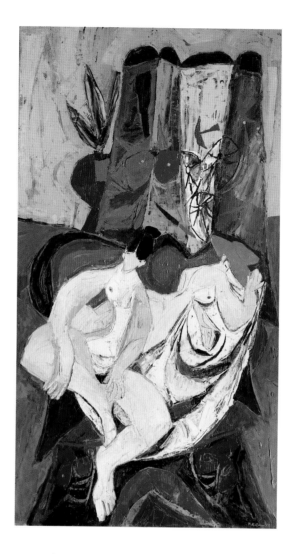

FIG. 9
Herbert Katzman
Two Nudes before Japanese Screen, 1952
Oil on composition board
76 x 43 inches (193 x 109.2 cm)
Whitney Museum of American Art,
New York; Purchase, with funds from
the Juliana Force Purchase Award

When curators from the United States had the opportunity to assemble shows of American art in Europe after the war, there was a comparable mix of traditional and avant-garde, figurative and abstract work. This pluralistic approach was taken by Kuh, who, in 1954, became The Art Institute of Chicago's first curator of modern painting and sculpture when she organized the American Pavilion of the 1956 Venice Biennale. Her exhibition, which took as its theme (and title) *American Artists Paint the City*,

ranged in its contents from the Social Realism of Shahn and the representational expressionism of Katzman to the Abstract Expressionism of de Kooning.[63] Katzman's *Brooklyn Bridge* of 1951–52, which had debuted four years earlier at the Downtown Gallery, provided a view of the modern metropolis that harked back to an earlier tradition of European Expressionism. De Kooning was represented by his painting *Gotham News* (1955), in which he had rendered the city in animated brushstrokes and, to create additional texture, had impressed areas with newspaper, which resulted in the ink transferring to the surface of the canvas. It was the extraordinary addition of the traces of newsprint that led Kuh and de Kooning to jointly choose the painting's title.[64] On the one hand, de Kooning's painting was the quintessential gesture painting for which Abstract Expressionism had become known, and on the other, the introduction of the newsprint pointed to new directions in contemporary art that would blur boundaries and bring everyday elements into the artistic realm.

Nearly a decade after the first generation of Abstract Expressionists had reached their signature styles, The Museum of Modern Art dedicated its first comprehensive exhibition to the movement. *The New American Painting: As Shown in Eight European Countries, 1958–1959*, curated by Miller,[65] was arranged at the behest of European curators and organized under the auspices of The Museum of Modern Art's International Program. The exhibition's tour of eight European countries concluded with a presentation in New York in 1959. It was a watershed moment for Abstract Expressionism. Seven years after the *Fifteen Americans* exhibition, even conservative critics acknowledged, somewhat disparagingly, that Abstract Expressionism was the "certified contemporary art style so far as museums, the critics, and the big investors in modern painting are concerned."[66] With hindsight, Serge Guilbaut, in his book *How New York Stole the Idea of Modern Art* (1983), posited that the American export of Abstract Expressionism was a player in Cold War politics. This avant-garde art, he suggested, conveyed

the message that American hegemony in the postwar period was not only political and economic, but also cultural. While it was also argued that the acceptance of diverse styles was indicative of American freedom of expression, for Guilbaut and other scholars, it was the freely painted abstractions that embodied this message.[67] By this argument, the work of representational artists, by contrast, was rendered politically useless.

The premium placed on the avant-garde, on art that broke with the establishment rather than that which was rooted in time-honored traditions, was precisely what Elaine de Kooning had railed against in her defense of Dickinson. Katzman's work was similarly sidelined because of the myopia of major critics and the emphasis on innovation of style. Whereas the Whitney's *The New Decade: 35 American Painters and Sculptors* exhibition in 1955 displayed abstract and figurative art side by side with "abstract artists for whom the figure was central to their imagery" (including de Kooning and Katzman), four years later, the Annual favored abstraction to such an extent that figurative artists were compelled to write a letter of protest to Lloyd Goodrich, the museum's director.[68] At The Museum of Modern Art, Miller's *Americans* series continued to promote abstraction in *Twelve Americans* in 1956 and *Sixteen Americans* in 1959. In the latter exhibition, however, Miller introduced the hard-edged abstractions of Frank Stella's stripe paintings, as well as the work of Jasper Johns and Robert Rauschenberg. By crossing lines between media and by reintroducing commonplace subjects and materials, Johns and Rauschenberg would be instrumental in toppling the reign of pure abstraction. Art in the 1960s moved toward a realism quite different from Katzman's: the use of everyday materials in art and what became known as Pop art, which incorporated the subjects, styles, and methods of the mass media.

In his last solo exhibition at The Alan Gallery in November of 1959, Katzman showed paintings that were almost completely abstract, yet with subjects still anchored to the city and people

around him. About his paintings from this period, such as *New York Skyline* (1958, fig. 10), Katzman wrote:

> I've continued painting landscapes, mostly of Brooklyn bridge, and it has become a very important motif for me. Over the years I think it has continued to change and I hope develop. The skyline has become a curved diagonal stroke, the buildings only irregular horizontal strokes, and the bridge another diagonal stroke. Why not a more realistic view? . . . To paint a realistic picture simply for the sake of so-called realism is as stupid as painting an abstract one simply for the sake of abstraction. . . . My less real landscapes have more of the feel of the thing.[69]

Katzman's foray into near pure abstraction, however, was short-lived, and after a series of gray color-field landscapes of New York harbor (plates 6–8), he returned in the 1970s to representational imagery. Regarding a later body of work (including sketches and both small and large paintings), he wrote a description that came close to his statement in *Fifteen Americans:*

> I am doing a series of New York City landscapes transmitting the power and tension which I feel is New York. . . . I have to work with an objective view because if I give up the appearance of the world I find I am unable to become involved in it.[70]

At a time when Katzman had fallen from favor in a fickle art world, his friend, the sculptor Harold Tovish, wrote him a series of letters of encouragement. Tovish touched on why Katzman, with his commitment to an older artistic tradition, could not compete in an art scene that valued, above all else, the "irresistible attraction of the 'new.'"[71] Calling Katzman "the last Romantic in the grand style,"[72] Tovish mused:

> I suppose it is the frankly romantic nature of your work that dazzles them into blindness. They no longer know how to deal with it. If it ain't formalist . . . or irreverent . . . it is out of step with the times. The irony . . . is that your command of formal issues is masterful. You treat your subjects with dignity and a kind of gravity which has virtually disappeared from art. . . . They still think avant gardism is all that counts—the idea is to kill the past. . . . Art criticism is a business . . . hence the irresistible attraction to the "new." . . . I never saw Turner looming large in your paintings or the drawings. You have absorbed something from Turner . . . but to depict yourself as a sort of abject follower of the Master does you an injustice. And why Whistler? Why not

> Degas? Or somebody else—Manet, maybe. Your stuff doesn't look like theirs—it is unmistakenly yours. . . . You are in the grand tradition.[73]

Katzman continued to show his work commercially through the early 1990s, however, some of his very best paintings and works on paper were done after this time. Removed from the vagaries of the art world, he could perhaps then be truest to his own vision. In his spectacular cityscapes done in colored chalks and on contrasting colored papers (for example, Untitled (The Battery) [1995, plate 63]), he still maintains the imaginary, high-vantage point observable in his earliest renderings of the city. The curve of the buildings of Lower Manhattan and of the harbor have become etched in his memory, mutated into iconic forms that he could repeat at will in different colors, sizes, and mediums, from the small paintings to the tiny graphite drawings he made during the last two years of his life. As a reviewer wrote of one of Katzman's last shows, at Terry Dintenfass in 1993, he "create[s] realistic representations that nonetheless express the hazy feel of dreams and convey . . . emotion and introspection."[74] In the renderings from the last decade of his life, Katzman depicts Lower Manhattan in iconographic shorthand, emerging splendidly from the clouds, mist, and pollution. It is these vaporous and ethereal conditions that so eloquently convey the modern, urban experience.[75]

My thanks go to Emily Braun and Susan Davidson who graciously read early drafts of this essay and who, as always, provided invaluable insights and suggestions.

1 Lyonel Feininger, letter to Dorothy C. Miller, June 12, 1952, Dorothy C. Miller Papers [hereafter DCM], I.6.d. The Museum of Modern Art Archives, New York. The bracketed "[no]" is handwritten in the typed letter.

2 For an excellent overview of the *Americans* series see Lynn Zelevansky, "Dorothy Miller's 'Americans,' 1942–63," in *The Museum of Modern Art at Mid-Century: At Home and Abroad* (New York: The Museum of Modern Art, 1994), pp. 57–96, 98–107. Note that this book is also referred to as volume 4 of the journal *Studies in Modern Art*.

3 Robert Rosenblum, *A Curator's Choice 1942–1963: A Tribute to Dorothy Miller*, exh. brochure (New York: Rosa Esman Gallery, 1982), unpaginated.

4 A more recent study of American art during the 1950s that acknowledges the rich diversity of art during this period is Jed Perl, *New Art City: Manhattan at Mid-Century* (New York: Vintage Books, 2007).

5 James Kearns, who became Katzman's colleague at the School of Visual Arts, New York, in 1960, was also an alumnus of the School of the Art Institute of Chicago. Arriving just after Katzman had graduated in 1946, Kearns recalls how the school was still talking about Katzman and his skill as a painter and draftsman. Conversation with the author, November 1, 2009.

6 See Geoffrey Jacques, "Galerie Huit," in *Galerie Huit: American Artists in Paris 1950–52*, exh. cat. (New York: Studio 18 Gallery, 2002), pp. 4–9.

7 Herbert Katzman, notes on *The Seine* (1949), Museum Collection Files, Department of Painting and Sculpture, The Museum of Modern Art, New York.

8 Howard Devree, "Modern Angles: New Shows that Reflect Contemporary Quest," *The New York Times*, March 9, 1952.

9 See Herbert Katzman, interview with unknown person at Tanglewood Music Center, Lenox, Massachusetts, 1968 (audio recording in Katzman family archives), and Katzman, interview by Janice Becker, insert to *Herbert Katzman: Retrospective Paintings and Drawings*, exh. cat. (New York: Artists' Choice Museum, 1985).

10 Gay R. McDonald, "The Launching of American Art in Postwar France: Jean Cassou and the Musée National d'Art Moderne," *American Art* 13, no. 1 (Spring 1999), pp. 54–55. I am grateful to Katherine E. Manthorne for referring me to McDonald's work.

11 Perl, *New Art City*, pp. 17–19.

12 Irving Sandler, "Introduction," in *Defining Modern Art: Selected Writings of Alfred H. Barr, Jr.*, ed. Sandler and Amy Newman (New York: Harry N. Abrams, 1986), p. 31. Also in this volume, see Alfred H. Barr, Jr., "Is Modern Art Communistic?," pp. 214–19. Originally published in *The New York Times Magazine*, sec. 6, December 14, 1952.

13 See Michael Leja, "The Formation of the Avant-Garde in New York," chapter one in *Reframing Abstract Expressionism: Subjectivity and Painting in the 1940s* (New Haven: Yale University Press, 1993), pp. 18–48.

14 Clement Greenberg, "Abstract, Representational, and so forth," in Greenberg, *Art and Culture: Critical Essays* (Boston: Beacon Press, 1961), pp. 133–35. Originally published in *Art Digest*, November 1, 1954. For an overview of the debates over abstract versus figurative art during this period see Charlotte Eyerman, "Abstraction and Representation: A Brief History," in *Action/Abstraction: Pollock, De Kooning, and American Art, 1940–1976*, ed. Norman L. Kleeblatt, The Jewish Museum, New York, exh. cat. (New York: Yale University Press, 2008), pp. 231–45.

15 Clement Greenberg, "'American-Type Painting," 1955/58, in *Art and Culture*, p. 209. Originally published in *Partisan Review* (Spring 1955).

16 Sandler, "Introduction," pp. 10, 13. Alfred H. Barr, Jr. had been in Russia in the 1920s and again in the 1950s, and in Germany in 1933.

17 Charles Alan, in oral history interview with Charles Alan by Paul Cummings, August 20–25, 1970, Archives of American Art, Smithsonian Institution, Washington, D.C.

18 T[homas] B. H[ess], "Young Midwest Painters," *Art News* 50, no. 3 (May 1951), p. 57.

19 Robert M. Coates, "Young Contemporaries and Old Masters," The Art Galleries, *The New Yorker*, May 12, 1951, p. 90.

20 Aline B. Louchheim, "Conclusions from a Chicago Annual: Validity and Diversity of Our Art Upheld in Invited Show," *The New York Times*, October 28, 1951.

21 C. J. Bulliet, "Chicago Invites and Rewards Abstract Art," *The Art Digest* 26, no. 4 (November 15, 1951), p. 8.

22 I would like to thank Emily Braun for her thoughts and conversations on this topic.

23 Katherine Kuh, *My Love Affair with Modern Art: Behind the Scenes with a Legendary Curator*, ed. Avis Berman (New York: Arcade Publishing, 2006), pp. 29–30.

24 Eleanor Jewett, "60th Exhibit in Art Institute Features Fads," *Chicago Daily Tribune*, sec. 3, October 24, 1951.

25 C. J. Bulliet, "Indignation in Chicago," *The Art Digest* 26, no. 4 (November 15, 1951), p. 8.

26 Louchheim, "Conclusions from a Chicago Annual."

27 "New Crop of Painting Protégés: Dealer with an Eye for Talent Tries to Pick Tomorrow's Stars," *Life* (March 17, 1952), p. 87.

28 Gordon Washburn, letter to Herbert Katzman, June 2, 1952, Katzman family archives. Regarding his entry, see Peter Hastings Falk, ed., *Carnegie Institute's International Exhibitions: 1896–1996* (Madison, Conn.: Sound View Press, 1998), p. 176.

29 Dorothy C. Miller, letter to Herbert Katzman, January 18, 1952, DCM, I.6.a. The Museum of Modern Art Archives, New York.

30 Herbert Katzman, letter to Dorothy C. Miller, January 23, 1952, ibid.

31 [Dorothy] Dudley, memo to Dorothy C. Miller, January 28, 1952, DCM, I.6.f. The Museum of Modern Art Archives, New York.

32 Dorothy C. Miller, "Foreword," in *Fifteen Americans*, ed. Miller, exh. cat. (New York: The Museum of Modern Art, 1952), p. 5.

33 Dorothy C. Miller, "Dorothy Canning Miller," statement in Lynn Gilbert and Gaylen Moore, *Particular Passions: Talks with Women Who Have Shaped Our Times* (New York: Clarkson N. Potter, 1981), p. 27.

34 Miller, "Foreword," p. 5.

35 Press release for *Fifteen Americans*, The Museum of Modern Art, New York. Department of Public Information Records [hereafter PI], II.B.87. The Museum of Modern Art Archives, New York.

36 Miller, "Foreword," p. 5.

37 Dorothy C. Miller, interview by Avis Berman, May 4, 1981, part of "Mark Rothko and His Times," oral history project sponsored by the Archives of American Art, 1980–85, quoted in Zelevansky, "Dorothy Miller's 'Americans,' 1942–63," p. 71.

38 William Baziotes, statement in *Fifteen Americans*, ed. Miller, p. 12. This is a reprint of the artist's text "I Cannot Evolve Any Concrete Theory," *Possibilities* 1 (Winter 1947–48), p. 2.

39 Clement Greenberg, "Review of Exhibitions of Mondrian, Kandinsky, and Pollock; of the Annual Exhibition of American Abstract Artists; and of the Exhibition *European Artists in America*," in *Clement Greenberg: The Collected Essays and Criticism*, ed. John O'Brian, vol. 2, *Arrogant Purpose, 1945–1949* (Chicago: University of Chicago Press, 1986), pp. 16–17. Originally published in *The Nation*, April 7, 1945.

40 Jackson Pollock, taped interview by William Wright, 1950, broadcast WERI, Westerly, R.I., 1951, quoted in Leja, *Reframing Abstract Expressionism*, p. 37. Originally published in Francis V. O'Connor and Eugene V. Thaw, *Jackson Pollock: A Catalogue Raisonné of Paintings, Drawings, and Other Works*, vol. 4 (New Haven: Yale University Press, 1978), pp. 248, 250.

41 Mark Rothko, letter to the editor, *The New York Times*, sec. 2, July 8, 1945, quoted in ibid.

42 Zelevansky, "Dorothy Miller's 'Americans,' 1943–63," p. 72.

43 Elaine de Kooning, "The Modern Museum's Fifteen: Dickinson and Kiesler," in *Elaine De Kooning: The Spirit of Abstract Expressionism, Selected Writings* (New York: George Braziller, 1994), pp. 118, 120–21. Her text therein was incorrectly dated 1953; it first appeared in *Art News* in April 1952.

44 Herbert Katzman, statement, in *Fifteen Americans*, p. 39. In an earlier version of this statement, he said "I prefer to do objective painting." ("Objective" as opposed to "nonobjective"—a term used at the time to describe abstraction). Katzman, letter to Miller, January 23, 1952. Both the handwritten letter and the typed version are in DCM I.6.a. The Museum of Modern Art Archives, New York.

45 Miller, "Dorothy Canning Miller," p. 27.

46 Dorothy C. Miller, memo to Dorothy Dudley, June 3, 1952; Richard Blow, letter to Alfred [H. Barr, Jr.], October 3, 1952; Dorothy C. Miller, letter to Helene Loeffler, August 20, 1952, DCM, I.6.d. The Museum of Modern Art Archives, New York.

47 Rothko's *No. 10* (1950), Museum Collection Files, Department of Painting and Sculpture, The Museum of Modern Art, New York. Also see Zelevansky, "Dorothy Miller's 'Americans,' 1942–63," p. 90.

48 A. L. Chanin, "The World of Art: Art Styles Clash and Clang In Show of 'Fifteen Americans,'" *The Compass*, April 13, 1952.

49 Emily Genauer, "Exhibits of Church Art, da Vinci Inventions, Modern Museum Choices," Art and Artists, *New York Herald Tribune*, sec. 4, April 13, 1952.

50 Thomas B. Hess, "The Modern Museum's Fifteen: Where U.S. Extremes Meet," *Art News* 51, no. 2 (April 1952), p. 17.

51 Robert M. Coates, "Seventeen Men," The Art Galleries, *The New Yorker*, May 3, 1952, p. 97.

52 James [Thrall] Soby, letter to Richard Blow, June 4, 1952, DCM I.6.d. The Museum of Modern Art Archives, New York.

53 Alfred H. Barr, Jr., letter to Robert M. Coates, May 31, 1952, PI, II.B.87. The Museum of Modern Art Archives, New York.

54 Hermon More, "Foreword," in *Loan Exhibition of Seventy XX Century American Paintings*, exh. cat. (New York: Wildenstein Gallery, 1952). Quoted in Beth Venn, "Taking Inventory: Art of the Early Fifties," in *A Year from the Collection, Circa 1952*, exh. brochure (New York: Whitney Museum of American Art, 1994), not paginated. William Baziotes's *Sea Forms* (1951) and Willem de Kooning's *Woman and Bicycle* (1952–53), both of which entered the Whitney collection in the 1950s, are examples of abstract works that retain references to the figure or landscape.

55 Howard Devree, "Acquisitions at Whitney—Robinson Collection," *The New York Times*, March 8, 1953.

56 Howard Devree, "Two In Contrast: The Quiet Marquet, the Dynamic Corinth at Their Best—Pennsylvania Annual," *The New York Times*, January 25, 1953.

57 "The Whitney Museum in Its New Home," *The New York Times*, October 31, 1954.

58 Editor [Jean Lipman], "Foreword . . . Americans with a Future," *Art in America* 42, no. 1 (Winter 1954), p. 10.

59 Patricia Hills and Roberta K. Tarbell, "The 1950s New York Art Scene and the 'Triumph' of Abstract Expressionism," in *The Figurative Tradition and the Whitney Museum of American Art: Paintings and Sculpture from the Permanent Collection*, exh. cat. (New York: Whitney Museum of American Art, in assoc. with the University of Delaware Press, Newark, and Associated University Presses, London and Toronto, 1980), p. 122.

60 "Katzman at Alan," *New York Tribune*, October 1954.

61 Robert M. Coates, "Fast Start," The Art Galleries, *The New Yorker*, October 16, 1954, p. 76.

62 S. Lane Faison, Jr., "Art," *The Nation*, October 23, 1954.

63 Katherine Kuh, ed., *American Artists Paint the City*, American Pavilion, 28th Venice Biennale, exh. cat. (Chicago: The Art Institute of Chicago, 1956).

64 Kuh, *My Love Affair with Modern Art*, p. 233.

65 A catalogue was published in conjunction with the exhibition at the Tate Gallery, London, and was reprinted for the New York presentation *The New American Painting: As Shown in Eight European Countries, 1958–1959* (New York: The Museum of Modern Art, 1959). It includes an introduction by Barr and excerpts from European reviews of the exhibition.

66 Hilton Kramer, "The End of Modern Painting," *The Reporter*, July 23, 1959, quoted in Zelevansky, "Dorothy Miller's 'Americans,' 1943–63," p. 89.

67 Serge Guilbaut, *How New York Stole the Idea of Modern Art: Abstract Expressionism, Freedom, and the Cold War*, trans. Arthur Goldhammer (Chicago: The University of Chicago Press, 1983).

68 Hills and Tarbell, "The 1950s New York Art Scene and the 'Triumph' of Abstract Expressionism," p. 122. See also, *The New Decade: 35 American Painters and Sculptors*, ed. John I. H. Baur, exh. cat. (New York: Whitney Museum of American Art, 1955).

69 Herbert Katzman, statement, in *Art USA Now*, ed. Lee Nordness, vol. 2 (Lucerne: C. J. Bucher, 1962), half-page insert between pp. 396–97.

70 Herbert Katzman, "Project," typed note, undated, Katzman family archives.

71 Harold Tovish, letter to Herbert Katzman, July 15, 1981, Katzman family archives.

72 Harold Tovish, letter to Herbert Katzman, December 10, 1989, Katzman family archives.

73 Tovish, letter to Katzman, July 15, 1981.

74 Rachel Blustain, "Internal Landscapes: Herbert Katzman Sketches Portraits of Emotion," *Forward*, November 26, 1993.

75 See Marshall Berman, *All That is Solid Melts Into Air: The Experience of Modernity* (New York: Simon and Schuster, 1982), p. 144. Berman describes how the 19th-century French poet and critic Charles Baudelaire used "fluidity ('floating experiences') and gaseousness ([which] 'envelops and soaks us like an atmosphere') [as] symbols of for the distinctive qualities of modern life."

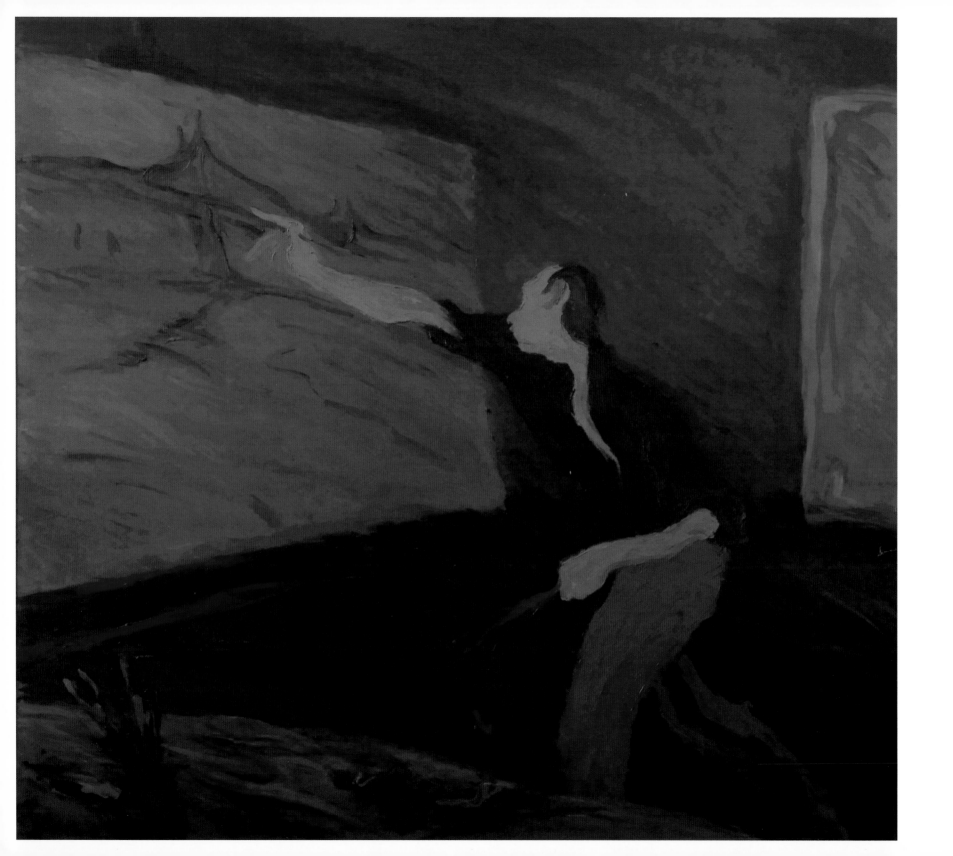

METROPOLIS AS MUSE

KATHERINE E. MANTHORNE

A picture of the New York Harbor was sitting on Herbert Katzman's worktable when he died on October 15, 2004. It was one of the many small graphite drawings he created during the last two years of his life, many measuring no more than 2 by 3 inches. The subject relates to *Brooklyn Bridge* (plate 1), one of his important canvases of New York painted in 1951–52, shortly after moving there. In this earlier work, the thickly applied paint evokes rather than describes the bridge, which structures the broad areas of expressionist color. In the half century in between these two works, the artist repeatedly rendered the city he made his home. He changed mediums over time, moving from heavily textured oils in his early work to graphite on paper in his final years. With this move from brush to pencil came a shift in his spatial perspective, coloristic effect, and emotional content. Yet a fascination with his adopted city remained the mainstay of his art.

The island of Manhattan covers a mere 23 square miles. Its streets and neighborhoods are nonetheless so varied in terrain, architecture, and sense of place that it offers multiple experiences in one. Every resident of the city conceptualizes it personally; everyone has her or his New York. Katzman found his New York in its waterways and bridges spanning the Hudson and East Rivers, and demonstrated a particular fondness for the waterfront at the southern tip of the island, with its view of the Statue of Liberty. This scenery is not unique to him; it is composed of iconic images that are staples of art and literature. So, we must look beyond subject matter alone if we are to discover Katzman's New York.

Residents of Westbeth Artists Housing, where Katzman resided since 1971, just one year after the building opened as artists' accommodations, recalled that initially he had a studio with big windows that afforded abundant light and great views of the river. However, once he began to inhabit the space and to draw and paint there, he realized that it was not for him. He did not require perpetual access to the city panorama, nor strong and varying light illuminating its every detail—far from it. He wanted a darker, more secluded space that allowed him to picture the cityscape in his mind's eye, rather than one that confronted him with its unmediated reality. He often covered his windows with paper to block the light and moved to an apartment with fewer windows and less spectacular views.[1] From this apartment's recesses, he painted and repainted his canvases of the harbor as he chose to recall it.

KATZMAN'S METROPOLITAN MUSE

For Katzman, the city was not his *subject,* if by that we signify the literal transcription of its streets and buildings into art; rather it was his *muse,* meaning the spirit that inspired him. When we think of artists

his downtown studio. He left behind a stash of city views culled from magazines, as well as photographs taken by him, his daughter Ann Marie (Annie), and others (see pp. 129–39 in this exhibition catalogue). Although it is not usually possible to identify a direct correspondence between photographic source and painting, it seems that Katzman assembled from them several motifs and effects that he recombined repeatedly on canvas or paper. Over the years, his emphasis moved away from direct observation toward the syntax of artistic materials, interior experience, and memory.

AMERICAN ART AND THE CITY

The American Impressionists, including Childe Hassam (fig. 11) and Guy Wiggins, sometimes painted the city as snow fell or fog rolled in, moments that lent themselves to subdued effects. They shared this strategy with Katzman, whose longtime friend, the sculptor Harold Tovish, noted: "He has made several large chalk drawings of the city, obscured by smoke and fog; when the harsh and brittle image of a modern city is softened by nature."[2] But New York made its first consistent appearance as a subject for a school of art in the work of the Ashcan painters. Robert Henri (fig. 12) and John Sloan left their positions as newspaper illustrators in turn-of-the century Philadelphia to found this school of urban realist painters in New York. Perhaps because they came to the city by choice and did not grow up there, they explored it with a different degree of attention and feeling than did lifelong residents, and saw it with fresh eyes. They inserted the city's streets and working-class neighborhoods firmly into the fine-art repertoire and opened the doors to future experimentation with its ever-changing appearance.[3] The Chicago-born Katzman similarly made a conscious decision to relocate to the city, where he, too, was able to see it from a new perspective after growing up in the Midwest and living in Europe. Immediately upon his arrival, he began to make the city his own by configuring it in his sketchbooks and

FIG. 11

Childe Hassam
Winter in Union Square, 1889–90
Oil on canvas
18 ¼ x 18 inches (46.4 x 45.7 cm)
The Metropolitan Museum of Art,
New York, Gift of Ethelyn McKinney,
in memory of her brother,
Glenn Ford McKinney, 1943

painting cityscapes, we tend to conceive of them observing the motif directly, setting up an easel or perhaps making quick sketches on a drawing pad. Not so with Katzman. Consider the process that led to the creation of *View of Prague* (1948, fig. 3), one of his earliest cityscapes, done on his first trip abroad. He first became interested in the subject via a picture of the city in *Life* magazine that prompted him to travel to Germany and Czechoslovakia with his artist friend Andy Martin. When he got to Prague, he eschewed the immediacy of an on-the-spot study and instead took photographs and made sketches that served as aide-mémoire and source material for the series of cityscapes that he painted only after he returned to Paris. Once established, this preparatory practice continued unabated in New York. We wonder, in fact, if after a certain point in time it was even necessary for him to exit

art capital, but the city's artists always communicated in a wide range of visual languages, with realism and expressionism serving as continuous threads between them.[4]

When it came time to organize an exhibition for the United States Pavilion at the 1956 Venice Biennale, Chicago-based curator Katherine Kuh found in the city an ideal premise. As she explained:

> *American Artists Paint the City* seems an appropriate theme for a group of paintings which have developed chiefly from our own roots. Since American cities differ from those in Europe both in appearance and history, our painters have tended to evolve a personal method of interpreting them. This is not to say that European influences are absent from such works, but rather that native expression is here more strongly felt.[5]

Many art historians subsequently conceptualized art of the 1950s through the lens of style wars that set the Abstract Expressionists against the Realists, but for those living and working at this critical postwar juncture, it was more important that American artists were striving to distinguish themselves from their European counterparts.

The shared objective of many was to demonstrate America's aesthetic independence, and it was the city and not any particular style that provided a vehicle for such liberation. Deliberately blurring stylistic categories, Kuh hung Katzman's expressionistic rendering of the Brooklyn Bridge alongside work by Realists Hopper, Jack Levine, and O'Keeffe, as well as work by Abstract Expressionists such as Pollock. "Men like Franz Kline, Jackson Pollock and Willem de Kooning in no sense paint city scenes," she explained, "but their work emerges from New York where they live." Their enormous canvases, she insisted, "envelop one with the same insistence as the city itself."[6] America's most advanced art was identified with the city just at the time when Katzman was arriving on the scene as a professional artist. The metropolis's mushrooming influence catalyzed artists and writers to turn to its representation and seek key landmarks and symbols to stand for its whole. The Brooklyn Bridge offered just such a symbol.

canvases. His *Brooklyn Bridge* was an early attempt to forge an artistic language and sense of place to convey *his* New York.

After World War II, the United States took a more prominent position on the world stage. A new attention to cosmopolitan centers was evident in American art and literature in the 1950s. Among the nation's growing cities, none enjoyed the vogue of New York, which around the time of Katzman's arrival usurped the status that Paris had long held as the art center of the Western world. But a critical mass of American artists had always made New York a home base. A generation earlier than that of Katzman's included Stuart Davis, Edward Hopper, John Marin, and Georgia O'Keeffe, artists who continued to create realist-based images in the latter half of the century. They mixed with European émigrés and younger Americans arriving from around the country, such as Jackson Pollock, who hailed from Wyoming. Abstraction dominated the postwar scene and contributed to New York becoming the global

From its opening in 1883, John Roebling's engineering marvel initially spawned only a trickle of pictorial renderings. Then first-generation modernists of the 1910s and 1920s found its unique marriage of tradition and technology especially compelling, and they treated its Gothic arches turned into heavy stone towers supporting a web of modern steel cables as shape and pattern with increasing frequency. Throughout the 1930s and early 1940s, especially in photography, a documentary approach was favored. Then all that changed. A thriving postwar economy and flood of returning GIs and arriving migrants spurred a real-estate boom in New York. Between 1945 and 1970, the city's physical landscape changed radically, propelled in part by the rise of the automobile and the construction of up-to-date, high-volume roads and bridges along the city's periphery. "Brooklyn Bridge, which is old (elevateds, cars, trucks, pedestrians all have special lanes), is as strong and rugged as a gladiator," the architect Le Corbusier declared, "while George Washington Bridge, built yesterday, smiles like a young athlete."[7] In 1950, the city closed the bridge for remodeling, and the following year Katzman created his early masterpiece *Brooklyn Bridge,* in which its structure spans the green, thickly troweled water of the East River and merges with Manhattan's architecture beyond. At this formal juncture, his nearly square canvas represents the collision between his recent experiences in Europe (the Old World) and his first impressions of New York (his New World). This duality echoes the bridge itself, with its stone towers reminiscent of a French Gothic cathedral combined with a network of cables, the product of American technology.

When the bridge reopened in 1954, it became a lightning rod for debate that had swirled around the island since the era when the bridge was erected: how to preserve the past while forging ahead with the new. To make the bridge safe for 20th-century motor traffic, engineers sacrificed what the poet Hart Crane has called its "inviolate curve;" it now slumped where it used to soar.[8] As American mass culture proliferated, the bridge's instant-recognition factor lent itself to everything from advertising and comic books to movie posters. Always one to go against the grain of prevailing artistic trends, Katzman may have returned to his early motif in order to snatch it from the jaws of popular culture and reclaim it for fine art. Thereafter he returned to its form again and again, mostly as a silhouette in the middle ground of his pictures, defining space and marking place. In these pictures, New York is a watery realm—the riverscape between Brooklyn and Manhattan.

CITY OF CINEMA

American cinema demonstrates an ongoing fascination with New York. From the first production of moving pictures in the city in 1896, its streets provided both setting and subject for an array of black-and-white silent movies. New York was in fact the movie capital of the United States until the midteens, when Hollywood emerged out of the desert outside Los Angeles, providing sunny skies and reliable outdoor filming conditions year round. Throughout the 1920s and 1930s, the "movie city" was a fabrication, a projection of New York built on studio sets in Hollywood. This changed in the summer of 1947 when *The Naked City* (1948, fig. 13) became the first feature film shot on location in New York in two decades.[9] It attracted huge crowds at its 107 filming sets around the city, and when the movie's opening scene rolled, audiences saw no titles or credits, just an airplane as it flew over Manhattan. Simultaneously, the voice of the proud producer explained:

> Ladies and gentlemen, the motion picture you are about to see is called *The Naked City.* My name is Mark Hellinger. I was in charge of its production, and I may as well tell you frankly that it's a bit different from most films you've ever seen. As you see, we're flying over an island, a city, a *particular* city. And this is the story of a number of people, and a story also of the city itself. It was not photographed in the studio. Quite the contrary. The actors played out their roles on the streets, in the apartment houses, in the skyscrapers of New York

Another line in the script went on to gain wider currency: "There are eight million stories in the Naked City. This has been one of them."[11] But it was the renewal of film's love affair with the look and feel of Manhattan that made it a milestone in cinema history, one that would impact the broader field of the visual arts.

There is an experience familiar to all moviegoers as we sit down in our seats and wait for an urban drama to start: we see a glimpse of Manhattan, usually at sunset or evening, as the sky darkens and the lights dotting the skyscrapers begin to twinkle. In movie-making parlance this is called the "establishing shot," the wide vista that identifies the setting. The New York skyline has opened more films than almost any other individual locale. Details of the shot vary: it could be a scene of midtown from the East River, downtown Manhattan from Brooklyn, or a sweep of the entire island with a lingering look at Central Park. Variations in site are not so much what matters, rather, the New York skyline is the unifying element; it is the signpost that identifies not only

America's largest city, but also stands in for the modern metropolis. This high aerial shot represented film's desire to penetrate the urban space and to transport the audience from the everyday world to the realm of movie magic.[12] Oil paintings by Katzman from the 1970s (when, as his daughter Annie recalls, his movie attendance rose), including *Brooklyn Bridge* (1974, plate 11) and *Brooklyn Bridge Sunset* (1978, plate 9), combine a panoramic view of the geography from above with detailed renderings of bridges, buildings, and shoreline configurations. These motifs are echoed in works created during the following decade, such as *Queensboro Bridge* (1988, plate 16). These pictures convey the grandeur of the city skyline, grounded in the specifics of individual landmarks; the colored canvases emulate cinema's bird's-eye views. But unlike the scenes in so many films, shot as if from the nose of an airplane, Katzman's position is imagined. He did not ascend to these heights, but worked from photographs and was inspired by such movies to create panoramas of the island city's perimeters.

Wall Street with its financiers and Madison Avenue with its advertising executives, as well as Fifth Avenue apartments with the domestic dramas of their wealthy inhabitants, were all featured in film. Then, in 1954, Elia Kazan exploded the old paradigms when he made *On the Waterfront.* It was distinguished by its presentation of the totality of the waterfront (not actually New York, but across the river in Hoboken, New Jersey)—from the rugged, floating shacks at water level to the streets hovering above it. Here again are analogies to Katzman's pictured universe. In *New York Harbor from Brooklyn Heights* (1978, plate 10) and Untitled (*View of Manhattan*) (1995, plate 64), the latter done in blue chalk on yellow paper, the artist took care to delineate the slips and docks that comprise this netherworld. *On the Waterfront*, "produced at the dawn of postwar filmmaking in New York . . . remains perhaps the most ambitious attempt ever to orchestrate the elements of an urban locale into a unified filmic setting."[13] A painter with Katzman's specific focus on the city's riverways would surely have been aware of this significant

FIG. 13
Actor Barry Fitzgerald
in *The Naked City* (1948)

filmic interpretation of its waterfront as an interface between city and river, the frontier between urban civilization and wilderness.

This is not to say that certain movies exerted a specific influence on Katzman's painting, but that they must have reinforced his decision to focus almost obsessively on this floating world. By midcentury, cinema had become a powerful cultural force and functioned as a huge visual database. *The Naked City* and *On the Waterfront* appeared around the time when Katzman first arrived in New York, but quickly became classics and were frequently replayed in the city's art-film houses. When in 1971 he moved into Westbeth, he must have been aware that the building had been, in a former life, Bell Labs, in which the first talking movies were screened.[14] By this time, Mayor John Lindsay had begun his efforts to attract the movie production business to New York, a campaign that succeeded in dotting the city streets, parks, and campuses with film crews. Their presence further blurred the boundaries between the reality of the city and its fiction in the pictorial arts: conditions that artists had to address as they painted locales that they knew first-hand, but which had become iconic through film.

An island city, Manhattan is connected to Long Island and the mainland by a network of bridges, many of which, not just the Brooklyn Bridge, make their appearance in Katzman's work. Filmmakers similarly love these soaring structures, which include the George Washington and Queensboro Bridges, and they make frequent appearances not only in opening shots but also as narrative elements. Take the 1991 movie *Queens Logic*, in which the main character, Al, tries and fails to relive his childhood triumph of climbing the Hell Gate Bridge. Given that his friend in the film is an artist who paints bridges from his apartment rooftop, and that the movie ends with a spectacular sunset over the Triborough Bridge and a stretch of Manhattan skyline compositionally not unlike Katzman's *Brooklyn Bridge Sunset*, it is tempting to assume an almost direct intersection between art and film.[15]

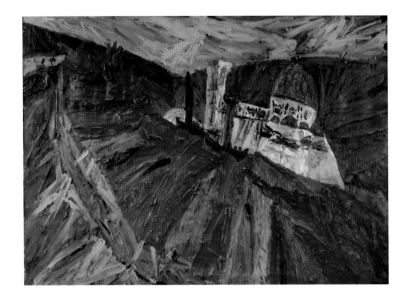

CITIES OF ART

Born January 8, 1923, Katzman spent his formative years, until he was 23, in Chicago. Even after he joined the Navy he was not deployed abroad, but, due to asthma, remained stateside and was stationed just outside the city. The "Windy City's" distinctive brand of civic pride and its cultural institutions had a definite hand in shaping the future artist and his worldview. Katzman's commitment to art began early, at age nine or ten, when his mother started bringing him to The Art Institute of Chicago for training. At that moment, from 1933 to 1934, Depression-era Chicago hosted the Century of Progress Exposition, a World's Fair that juxtaposed industrial and commercial displays with a major art exhibition mounted at The Art Institute. A big, sprawling, attention-grabbing show like this would have made a strong impression on a child just beginning to exercise his talent and to formulate his artistic calling. The Century of Progress would have been the kind of eye-opening experience for him that the first *International Exhibition of Modern Art* had been for the previous

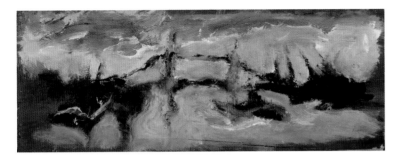

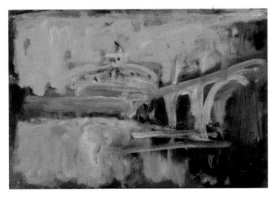

The painter Joan Mitchell, Katzman's friend from his student days, took classes at The Art Institute of Chicago with some of the same teachers as Katzman, including Boris Anisfeld and Louis Ritman. When asked what impact they had on her, she dismissed them in favor of the influence of the city's rich artistic holdings. "What was stimulating was the Art Institute—you just walk up the stairs and take a look at a good painting," she declared. Also, "there was the Arts Club . . . which was a fancy society thing then . . . but with [good] shows [like those centering on Constantin Brancusi or Georges Braque]."[18] It seems likely that her friend "Herby" (as she called him) had a similar response, especially given the evidence of his sepia chalk drawing *Two Friends at the Met* (1978, plate 50), which makes visible the idea of art as a shared experience between friends, something Katzman must have enjoyed with Mitchell in Chicago, and later, when they lived in the same apartment building in Paris.

Two Friends at the Met also underscores the importance of the tradition of observing art for his work. He found objects to study in The Metropolitan Museum of Art in New York, as we see here, as well as in The Art Institute of Chicago, and the Louvre in Paris, the city in which he lived from 1947 to 1950, supported in part by a traveling fellowship and funds from the GI Bill. From his Parisian base, he made trips to some of the major European cities of art, including Florence and London. Long after he had left these places, perhaps prompted by a magazine spread he saw or a postcard he received in the mail, he painted them, as in 1956, when he painted *Giotto Tower and Duomo* (fig. 14). Even into the 1990s he revisited England or Italy in his mind's eye and rendered their landmarks, sites anchored to the history of art, on a miniature scale, as in *London/Tower Bridge* (1997, fig. 15) and *Hadrian's Tomb (Castle S. Angelo)* (1997, fig. 16). These works also tell us that even when based on cities beyond New York, Katzman's pictures are about the power of place and memory.

generation. But the lesson here was different. "A showing of this kind—old masters and modern masterpieces—had never before been attempted in connection with a world's fair," one critic explained.[16] Past and present intermixed. Seeing a James Abbott McNeill Whistler hung near a Hans Holbein, a Paul Cézanne close by a Rembrandt, drove home the concept of a continuous art-historical tradition that led to a "large and amazingly well-chosen group of paintings by our American contemporaries which most eloquently attest the vitality of present-day native expression."[17] This formative event would have given Katzman the license to draw from the traditional and as well as the modern, a habit he retained for the remainder of his career.

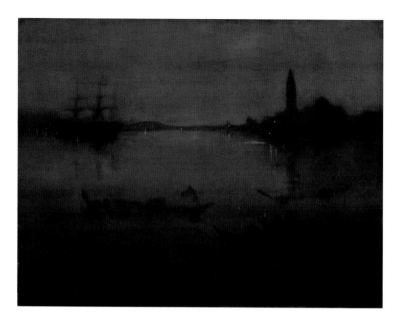

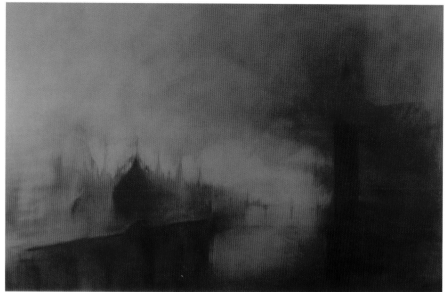

If Katzman had one foot firmly planted in the visual culture of his day, then the other was certainly anchored in the 19th century. This observation holds true both for the subjects he chose to paint and for the manner in which he chose to paint them. Two of the most prominent motifs in his New York views are 19th-century structures: the Brooklyn Bridge and the Statue of Liberty, which was completed in 1886. Then, too, there are artistic precedents. Writing on Katzman emphasizes his links to Expressionism, especially that practiced by Oskar Kokoschka and Chaim Soutine.[19] These artists unquestionably informed his method of "using a palette knife to lay down paint so thick 'its troughs and crests seem almost like a frozen sea,'" as a critic for *The New York Times* observed in 1951.[20] Equally important to him, to judge from the look of his pictures, was the art of the masters of the 19th-century American tradition, stretching from Hudson River School founder Thomas Cole to the expatriate Whistler.

Memory was always critical for artists, but it was not until the rise of Romanticism that it was privileged over descriptive skill and praised as a source of insight and emotion. Like Cole and Whistler, Katzman required distance and time to intervene between him and the objects of his study. We can almost hear him echoing the words that Cole wrote to his fellow landscapist Asher B. Durand in a letter of 1838:

> Have you not found, I have, that I never succeed in painting scenes, however beautiful, immediately on returning from them[.] I must wait for Time to draw a veil over the common details, the unessential parts, which shall leave the great features, whether the beautiful [or] the sublime, dominant in the mind.[21]

New York landmarks, such as bridges and the Statue of Liberty, appear in Katzman's work as shadows—distant and indistinct, like the traces of Venetian architecture that rim one of Whistler's nocturnes (fig. 17).

FIGS. 17, 18
James Abbott McNeill Whistler
Nocturne in Blue and Silver:
The Lagoon, Venice, 1879–80
Oil on canvas
19 ¾ x 25 ¼ inches (50.2 x 65.4 cm)
Museum of Fine Arts, Boston,
Emily L. Ainsley Fund
© 2010 Museum of Fine Arts, Boston

Herbert Katzman
San Marco II, 1981
Oil on canvas
45 ¼ x 71 ½ inches (115 x 181.6 cm)
Collection of the Katzman family

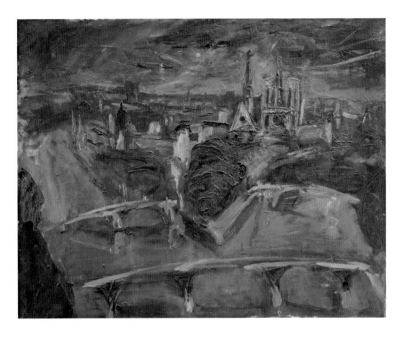

Whistler's imagery must have been on Katzman's mind when he rendered *San Marco II* (1981, fig. 18). Barbara Novak's observation, made about Whistler, that his "art was primarily an art of memory and synthesis," in fact applies equally to the 20th-century artist.[22] Katzman's cityscapes are similarly based not on things, but on thoughts and feelings conveyed in the swirling brushwork of his glorious skies. The artist often identified a picture as "Bay of New York," a phrase that is synonymous with New York Harbor, but less specific and more suggestive. His New York views resonate with the lines that close Walt Whitman's (Whistler's contemporary) poem *Mannahatta* (1860):

City of hurried and sparkling waters! city of spires and masts!
City nested in bays! my city![23]

FROM CITYSCAPE TO SKYSCAPE: IN THE FOOTSTEPS OF JAMES ENSOR

As a young artist in postwar Paris, Katzman painted *View of Paris (Notre Dame)* (1947, fig. 19), which already embodied his tendency to play the distinctive bridges and cathedral spires against the roiling landscape and sky. There he was in the thick of things, "erudite and enormously well read. He knew everyone in Paris," said Eric Protter, an editor of one of the city's literary magazines who met him there in 1948.[24] Yet Katzman eschewed the traditional audience with Pablo Picasso (whom so many of his generation had come to revere), and instead made a pilgrimage in 1948 to Belgium to the studio of James Ensor in the coastal resort town of Ostend. The time spent in the presence of the Expressionist master, he asserted, was one of the best hours of his life.[25] He made a portrait drawing of Ensor at the time, the year before the Belgian's death. Much later, in 1985, Katzman used that drawing as the basis for

FIGS. 19, 20
Herbert Katzman
View of Paris (Notre Dame), 1947
Oil on canvas
29 x 36 ⅛ inches (73.7 x 91.8 cm)
Collection of the Katzman family

Ensor Seated before
"The Entry of Christ into Brussels," 1985
Oil on canvas
55 ⅝ x 78 inches (141.3 x 198.1 cm)
Collection of the Katzman family

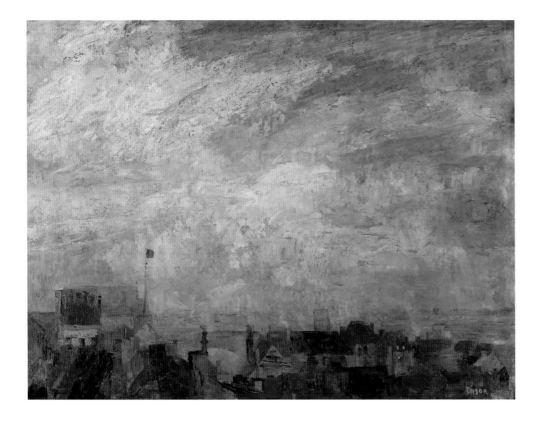

FIG. 21
James Ensor
Rooftops of Ostend
(Grand View of Ostend), 1884
Oil on canvas
58 11/16 x 81 inches (149 x 206 cm)
Koninklijk Museum voor Schone
Kunsten, Antwerp

an homage entitled *Ensor Seated before "The Entry of Christ into Brussels"* (fig. 20), a work summing nearly 40 years of contemplation of this complex, difficult-to-define figure. What lessons, we wonder, did Ensor impart to him?

Surveying Katzman's entire spectrum of New York pictures, we begin to realize that his outlines of harbor terrain and landmarks function as containers of space and especially light. In the end, he was not painting cityscapes, if by that we mean pictures that delight in delineating the physical contours of the urban environment. Rather he painted *skyscapes*. He might have varied the angle at which he viewed one of his bridges, or the segment of the island's shoreline that he had studied, but these geographic coordinates were secondary to the temporal and coloristic dimensions of the sky. This skyward orientation might well be part of Ensor's legacy to Katzman. Ensor's works demand much of their viewers. The Expressionist master did cityscapes early on, but moved beyond a single genre to become a multifaceted artist whose subjects ran the gamut from religious works and paintings of masks to a lifelong series of self-portraits. What unites them all, however, was his innovative and allegorical use of light. This is evident in his early cloud-filled landscapes, which convey the churning, ever-changing look of the sky and water below, as he would have observed them, living on the edge of the North Sea (fig. 21). And the importance of light was equally evident in his religious pictures, as when he transported Christ to the street of the Belgian capital.[26] Katzman perceived this relationship between painter and

place during his visit there and brought his insights back to the States, determined to forge parallel ties between himself and New York. Ensor's example inspired his American disciple's sustained engagement with the light and atmosphere of his island city.

1 Allison Armstrong, a resident of Westbeth Artists Housing, Greenwich Village, New York, in conversation with the author, August 2009. Information confirmed by Ann Marie Katzman.

2 Harold Tovish, untitled statement, in *Herbert Katzman: Retrospective Paintings and Drawings*, exh. cat. (New York: Artists' Choice Museum, 1985), p. 4.

3 See Heather Campbell Coyle and Joyce K. Schiller, *John Sloan's New York*, exh. cat. (Wilmington: Delaware Art Museum, in assoc. with Yale University Press, 2007), for a discussion of the Ashcan artists and their relation to the city.

4 For a useful overview of the period see Lisa Phillips, *The American Century: Art and Culture, 1950–2000*, exh. cat. (New York: Whitney Museum of American Art, in assoc. with W. W. Norton and Company, 1999).

5 Katharine Kuh, ed., *American Artists Paint the City*, American Pavilion, 28th Venice Biennale, exh. cat. (Chicago: The Art Institute of Chicago, 1956), p. 8.

6 Ibid., p. 31.

7 Le Corbusier, quoted in Richard Haw, *Art of the Brooklyn Bridge: A Visual History* (New York: Routledge, 2008), p. 204.

8 Hart Crane, *The Bridge: A Poem* (New York: Liveright, 1992), p. 1. First published in 1930.

9 Weegee (Arthur Fellig)'s book *Naked City* (New York: Essential Books, 1945) was made into the movie by Universal Pictures with Weegee acting as consultant.

10 James Sanders, *Celluloid Skyline: New York and the Movies* (New York: Alfred A. Knopf, 2001), pp. 330–31.

11 Ibid., p. 331.

12 Ibid., pp. 87–92.

13 Ibid., p. 349.

14 The history of the building can be found on the Westbeth Artists Housing website: Westbeth Artists Housing, http://www.westbeth.org.

15 Sanders, *Celluloid Skyline*, p. 363.

16 Malcolm Vaughan, "The Significance of the Century of Progress Art Exhibition," *Bulletin of the Art Institute of Chicago* 27, no. 5 (September–October 1933), p. 82.

17 Edward Alden Jewell, quoted in ibid., p. 86.

18 Joan Mitchell, oral history interview by Linda Nochlin, April 16, 1986, transcript, Archives of American Art, Smithsonian Institution, Washington, D.C., http://www.aaa.si.edu/collections/oralhistories/transcripts/mitche86.htm.

19 Tovish, untitled statement, p. 4.

20 Margalit Fox, "Herbert Katzman, 81, an Expressionist Painter," obituary, *The New York Times*, November 1, 2004.

21 Thomas Cole, letter to Asher B. Durand, Catskill, January 4, 1838, Cole Papers New York State Library, Albany. Quoted in Ellwood C. Parry, III, *The Art of Thomas Cole: Ambition and Imagination*, The American Arts Series (Newark: University of Delaware Press; London and Toronto: Associated University Presses, 1988), p. 201.

22 Barbara Novak, *American Painting of the Nineteenth Century: Realism, Idealism, and the American Experience*, 2nd ed. (New York: Harper and Row, 1979), p. 247.

23 Walt Whitman, "Mannahatta," in *Walt Whitman: Complete Poetry and Collected Prose* (New York: Literary Classics of the United States, 1982), p. 586. First published in 1860, revised edition published in 1881.

24 Eric Protter, quoted in "Herbert Katzman, 81, figurative artist, of Westbeth," *The Villager* 74, no. 26, October 27–November 3, 2004, http://www.thevillager.com/villager_78/herbertkatzman.html.

25 Herbert Katzman, interview with Mark Kristal and Phil Cates, in film by Cates, March 22–23, 2003, DVD, Katzman family archives.

26 For a recent discussion of James Ensor see Anna Swinbourne, ed., *James Ensor*, exh. cat. (New York: The Museum of Modern Art, 2009).

PAINTINGS

1
Brooklyn Bridge, 1951–52
Oil on canvas
54 x 60 inches (137.2 x 152.4 cm)
Collection of the Katzman family

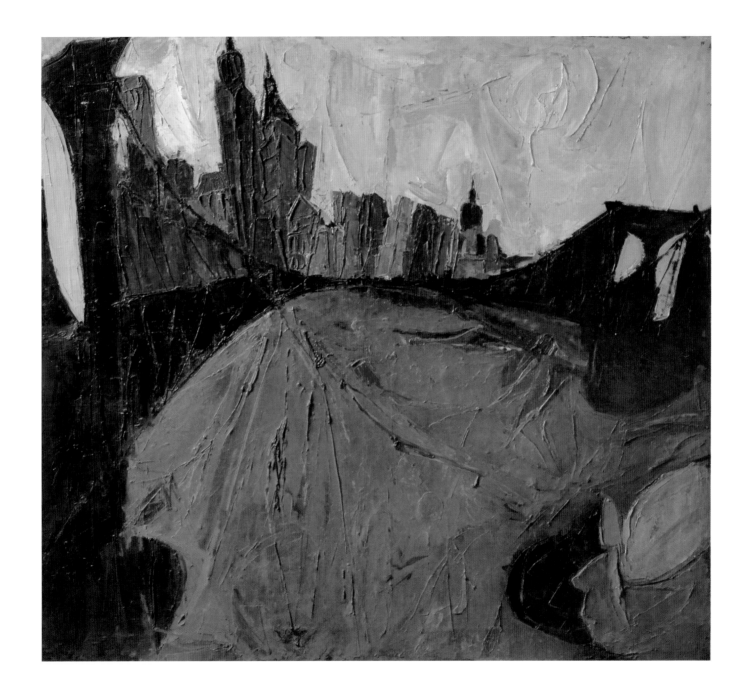

2
Untitled (New York Scene with Bridge),
ca. 1960
Oil on canvas
11 ⅛ x 24 ⅛ inches (28.3 x 61.3 cm)
Daniel and Joanna S. Rose

3
Brooklyn Bridge, 1961
Oil on canvas
36 ⅛ x 84 ⅛ inches (91.8 x 213.7 cm)
Collection of the Katzman family

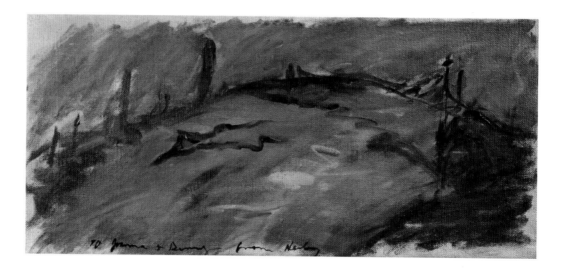

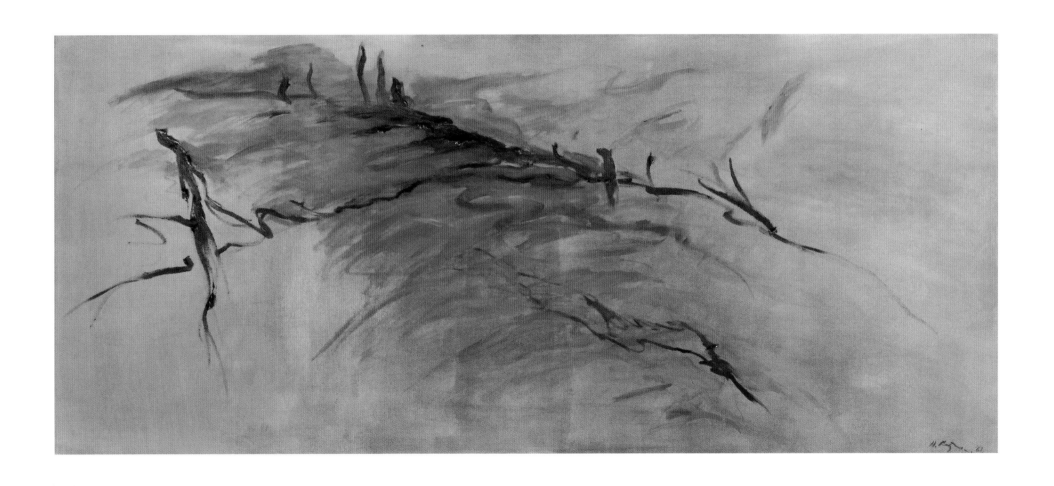

4
East River, 1965
Oil on canvas
22 x 54 inches (55.9 x 137.2 cm)
Private collection

5
Untitled (*New York Harbor*), 1963
Oil on canvas
45 ¾ x 83 ¼ inches (116.2 x 211.5 cm)
Daniel and Joanna S. Rose

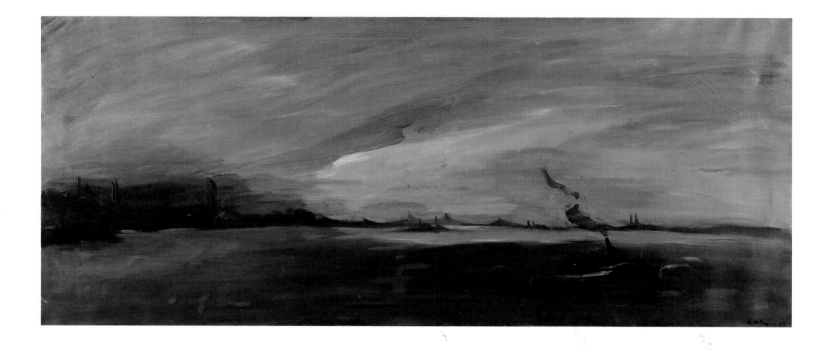

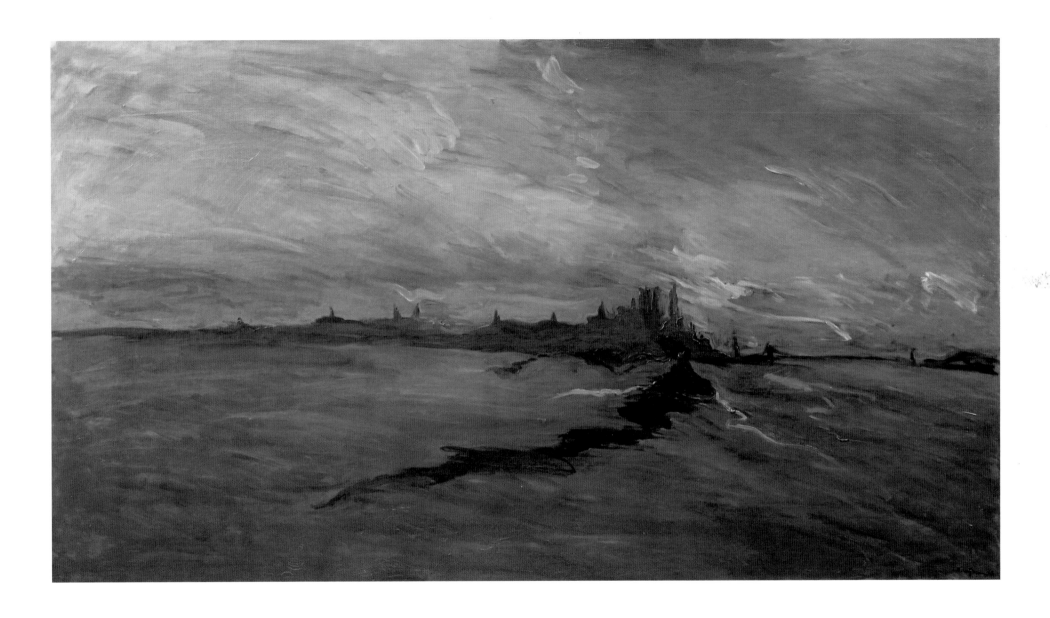

6
New York Bay 6, 1968
Oil on canvas
31 x 42 inches (78.7 x 106.7 cm)
Collection of the Katzman family

7
Untitled (*Study for QE2 Leaving
New York Harbor*), ca. 1967
Oil on canvas
8 x 10 inches (20.3 x 25.4 cm)
Collection of Steven Katzman,
San Rafael, California

8
New York Harbor, 1967
Oil on canvas
44 x 45 inches (111.8 x 114.3 cm)
Collection of Alison Lurie,
Ithaca, New York

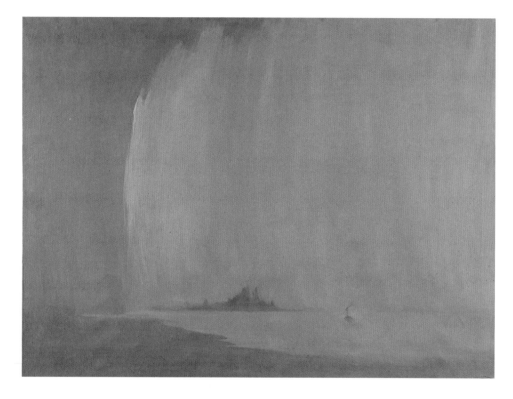
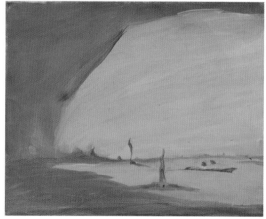

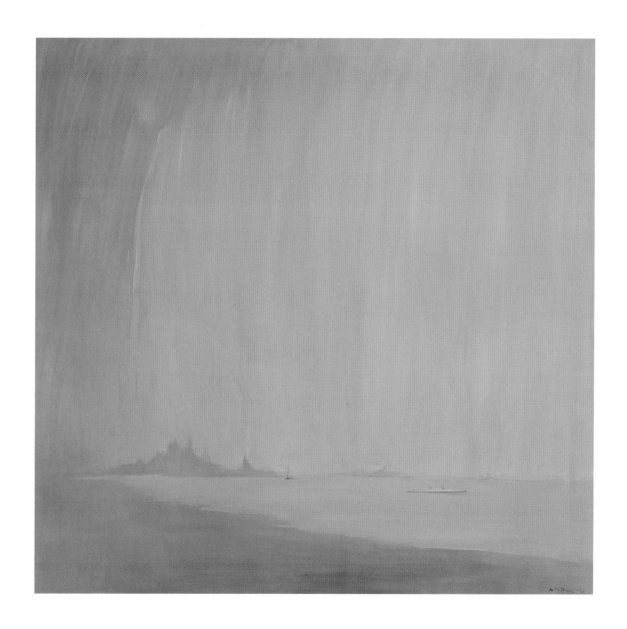

9
Brooklyn Bridge Sunset, 1978
Oil on canvas
33 ¾ x 80 inches (85.7 x 203.2 cm)
Courtesy of Terry Dintenfass, Inc.,
New York

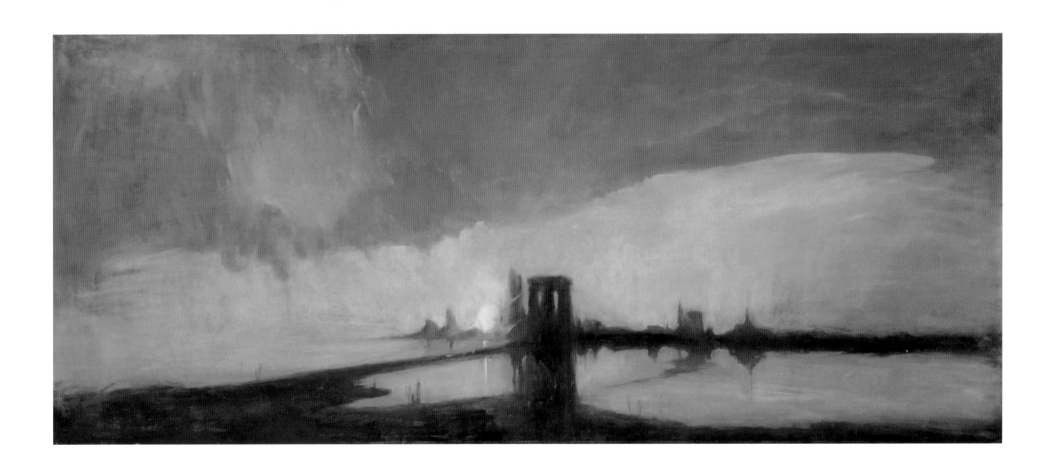

10
New York Harbor from
Brooklyn Heights, 1978
Oil on canvas
21 3/16 x 78 1/2 inches (53.8 x 199.4 cm)
Collection of the Katzman family

11
Brooklyn Bridge, 1974
Oil on canvas
60 x 72 inches (152.4 x 182.9 cm)
Collection of Mr. and Mrs. David S. Rose

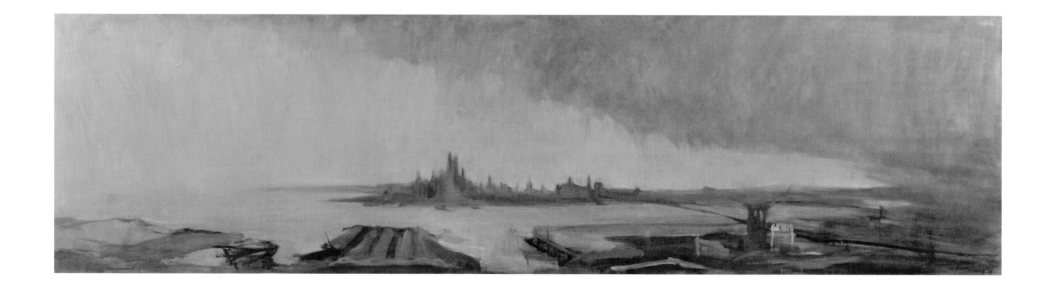

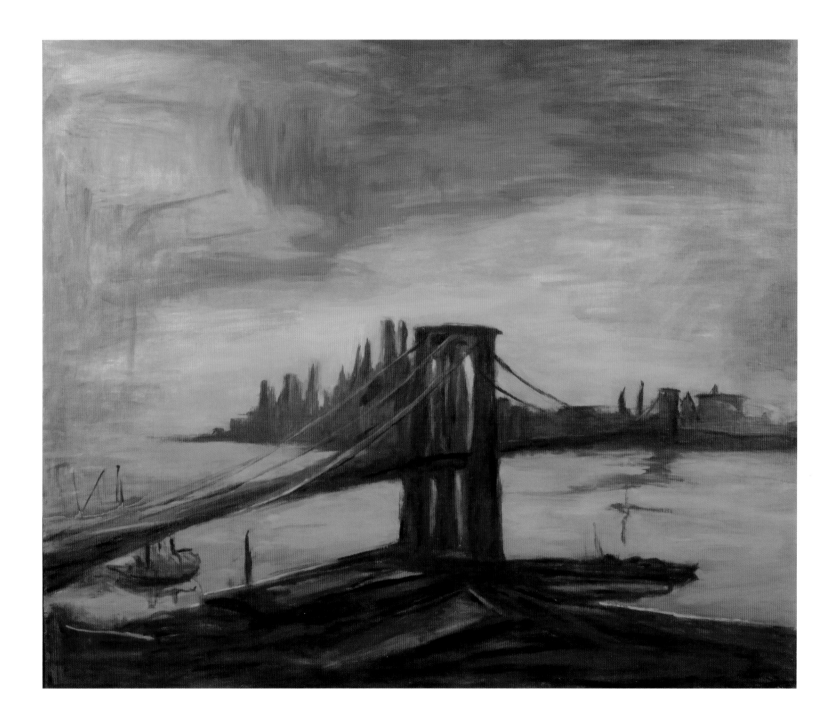

12
Fireworks on Hudson, 1976
Oil on canvas
62 x 84 inches (257.5 x 213.4 cm)
Collection of the Katzman family

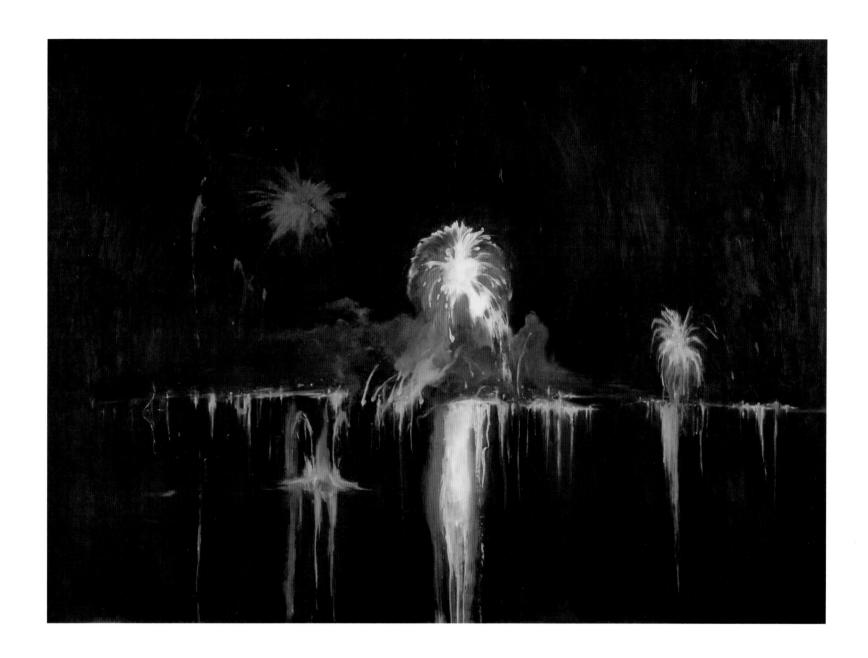

13
New York Seen from Staten Island, 1988
Oil on canvas
14 x 30 inches (35.6 x 76.2 cm)
Collection of the Katzman family

14
Statue of Liberty, 1983
Oil on canvas
33 ¾ x 62 ⅛ inches (85.7 x 157.8 cm)
Daniel and Joanna S. Rose

15 (above)
Queensboro Bridge, 1989
Oil on canvas, mounted on wood
10 ½ x 7 inches (26.7 x 17.8 cm)
Collection of the Katzman family

16 (below)
Queensboro Bridge, 1988
Oil on canvas, mounted on wood
6 ⁵⁄₁₆ x 11 ⅝ inches (16 x 29.5 cm)
Collection of the Katzman family

17 (facing page, left)
Untitled (*Queensboro Bridge*), 1996
Oil on wood
8 x 5 ½ inches (20.3 x 14 cm)
Collection of the Katzman family

18 (facing page, right)
Untitled (*Queensboro Bridge*), 1995
Oil on canvas, mounted on wood
6 ½ x 13 ⅝ inches (16.5 x 34.6 cm)
Collection of the Katzman family

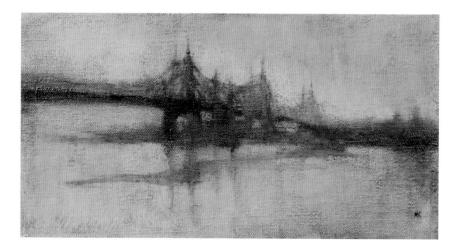

19
Tug Entering New York Bay, 1997
Oil on wood
3 ⅝ x 8 ¼ inches (9.2 x 21 cm)
Collection of the Katzman family

20
Staten Isle Ferry, 1989
Oil on canvas, mounted on wood
4 x 10 inches (10.2 x 25.4 cm)
Collection of the Katzman family

21
Staten Isle Ferry, Ochre, 1989
Oil on canvas, mounted on wood
5 ½ x 13 inches (14 x 33 cm)
Susan Subtle Dintenfass

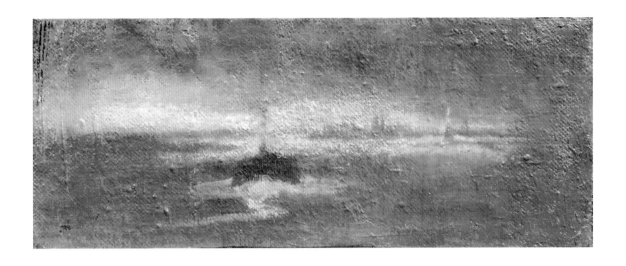

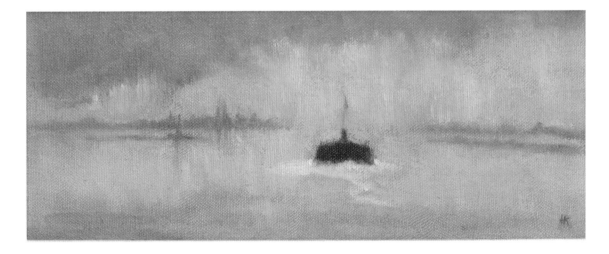

22
Fireworks/Statue of Liberty, 1996
Oil on canvas, mounted on wood
7 ½ x 6⅛ inches (19.1 x 15.6 cm)
Collection of the Katzman family

23
Fireworks over the Statue of Liberty, 1989
Oil on canvas, mounted on wood
7 ⅝ x 6 inches (19.4 x 15.2 cm)
Daniel and Joanna S. Rose

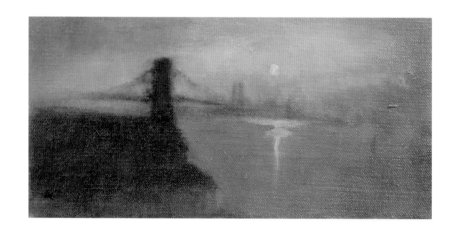

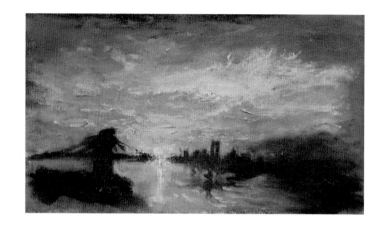

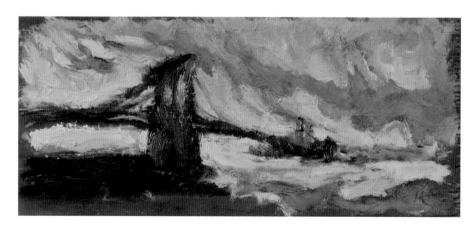

24 (facing page, far left)
Brooklyn Bridge—Sunset Grey, 1989
Oil on canvas, mounted on wood
5 ½ x 11 ³⁄₁₆ inches (14 x 28.4 cm)
Private collection

25 (facing page, near left)
Untitled (*Brooklyn Bridge*), 1995
Oil on canvas
7 ¾ x 12 ½ inches (19.7 x 31.8 cm)
Collection of the Katzman family

26 (facing page, below)
Untitled (*Brooklyn Bridge*), 1995
Oil on wood
3 ⅝ x 8 ¼ inches (9.2 x 21 cm)
Collection of the Katzman family

27 (at right)
Brooklyn Bridge Sunset, 1998
Oil on canvas
29 ⅝ x 33 ¼ inches (75.2 x 84.5 cm)
Collection of the Katzman family

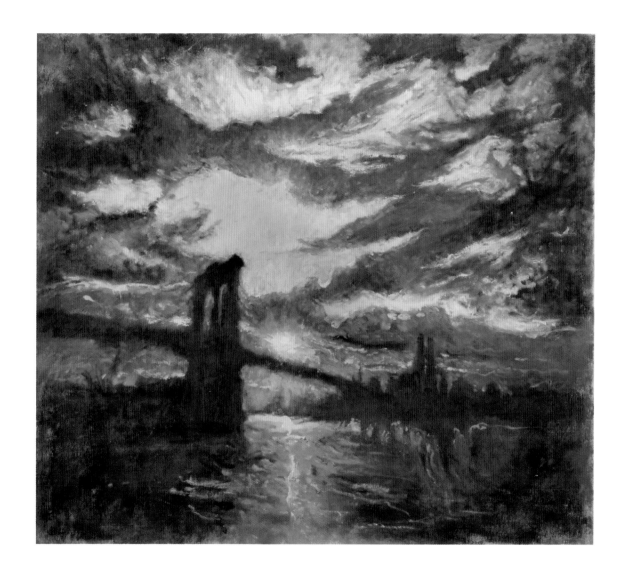

28
Brooklyn Bridge, 1998
Oil on canvas
42 ½ x 63 ¾ inches (108 x 161.9 cm)
Daniel and Joanna S. Rose

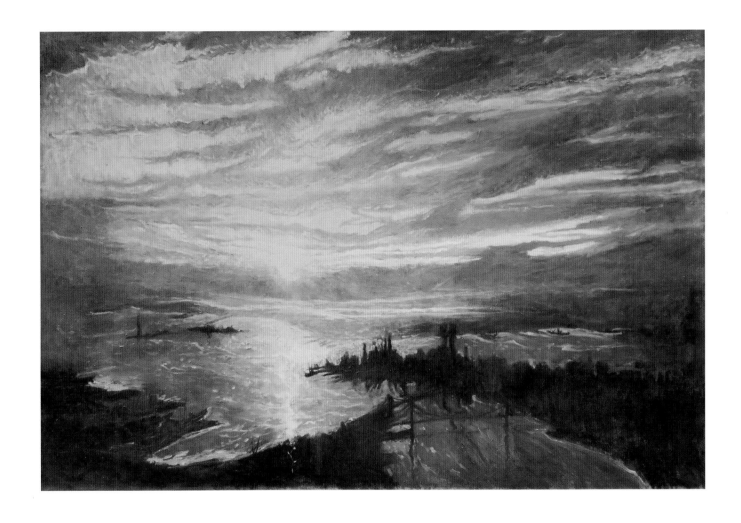

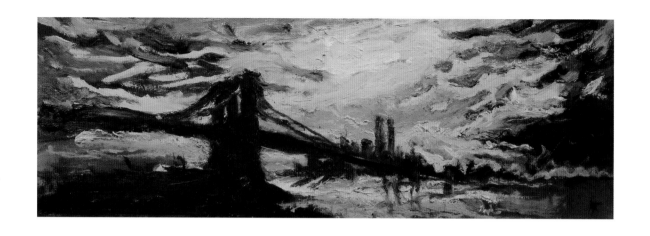

29 (facing page, above)
Untitled (Brooklyn Bridge), ca. 1995–97
Oil on wood
5 ⅜ x 16 ⅛ inches (13.7 x 41 cm)
Daniel and Joanna S. Rose

30 (facing page, near left)
Untitled (Brooklyn Bridge with
World Trade Center), ca. 1997
Oil on canvas, mounted on wood
5 ½ x 10 ⅞ inches (14 x 27.6 cm)
Daniel and Joanna S. Rose

31 (facing page, below)
Untitled (*Brooklyn Bridge*), 1996
Oil on canvas, mounted on wood
7 ⅞ x 14 ¾ inches (20 x 37.5 cm)
Collection of the Katzman family

32 (right)
Brooklyn Bridge, 1998
Oil on canvas
30 ⅜ x 34 ⅜ inches (77.2 x 87.3 cm)
Collection of the Katzman family

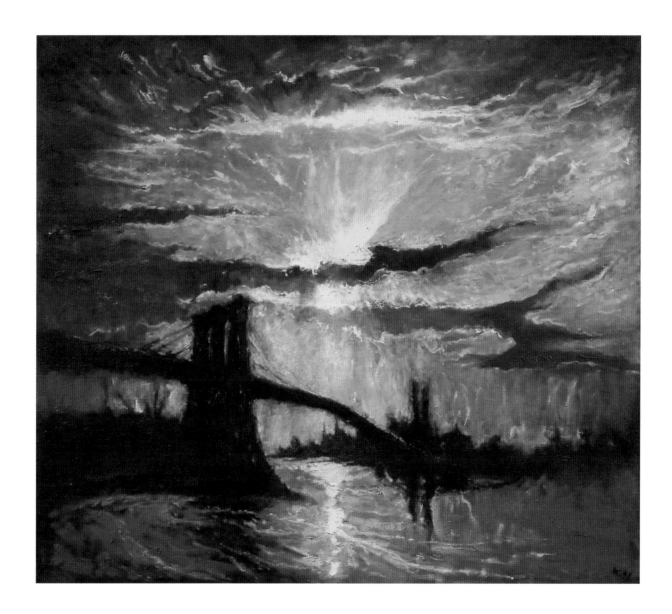

33
Boomerang Cloud, New York Bay, 1999
Oil on canvas
18 x 36 inches (45.7 x 91.4 cm)
Collection of Steven Katzman,
San Rafael, California

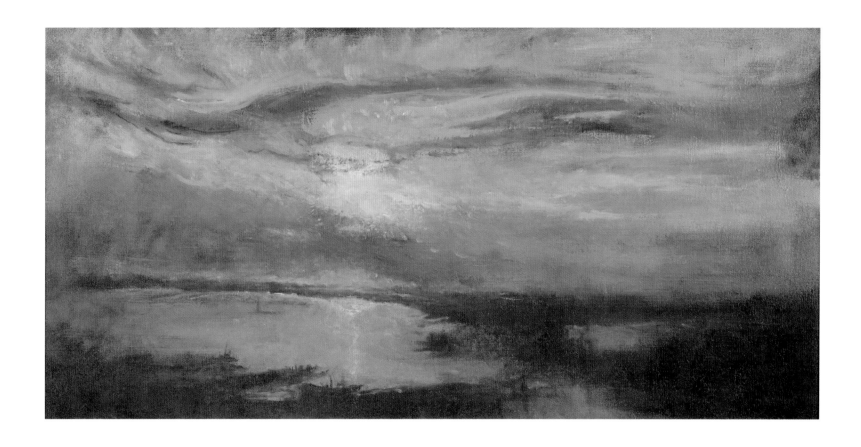

34 (above)
Untitled (*New York Bay/Lightning*),
July 11, 2000
Oil on canvas, mounted on wood
7 ⅛ x 13 ⅛ inches (18.1 x 33.4 cm)
Collection of the Katzman family

35 (center)
New York Bay, October 8, 2000
Oil on canvas, mounted on wood
6 ⅛ x 11 ½ inches (15.6 x 29.2 cm)
Collection of the Katzman family

36 (below)
Untitled (*New York Harbor/Sunset*),
1996
Oil on canvas, mounted on wood
8 x 15 ⅛ inches (20.3 x 38.4 cm)
Collection of the Katzman family

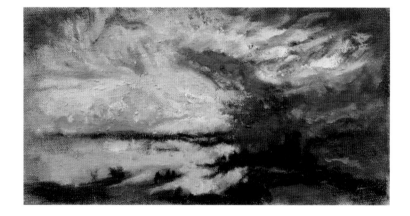

37
Untitled (New York Bay), 1997
Oil on canvas
11 ¾ x 24 ⅛ inches (29.8 x 61.3 cm)
Daniel and Joanna S. Rose

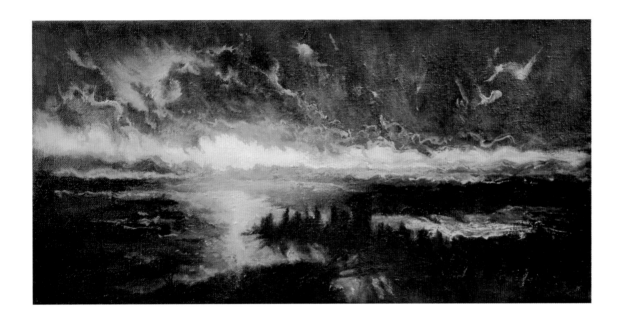

38 (this page, above)
Statue of Liberty, ca. 1995
Oil on canvas, mounted on wood
7 ⅝ x 11 inches (19.4 x 27.9 cm)
Collection of Steven and Jeanne
Katzman, San Rafael, California

39 (this page, below)
Untitled (*Statue of Liberty/Rainbow*),
1997
Oil on canvas, mounted on wood
5 ½ x 10 inches (14 x 25.4 cm)
Collection of the Katzman family

40 (facing page, above)
East River, 1989
Oil on canvas, mounted on wood
6 ¼ x 12 ⅞ inches (15.9 x 32.7 cm)
Collection of the Katzman family

41 (facing page, below)
Study for *Boomerang Cloud*
(*Birthday Card for Annie*),
October 27, 1997
Oil on canvas
12 x 24 inches (30.5 x 61 cm)
Private collection

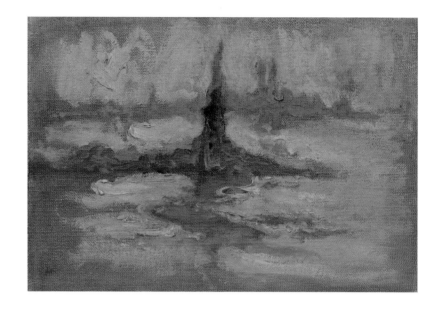

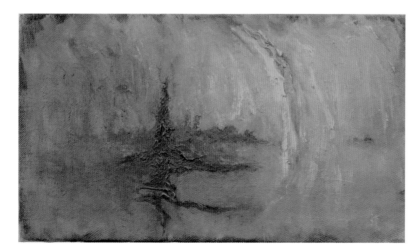

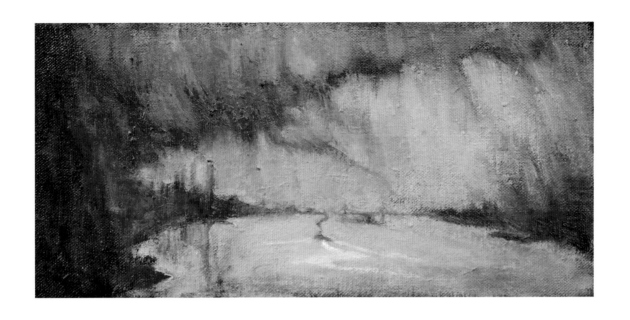

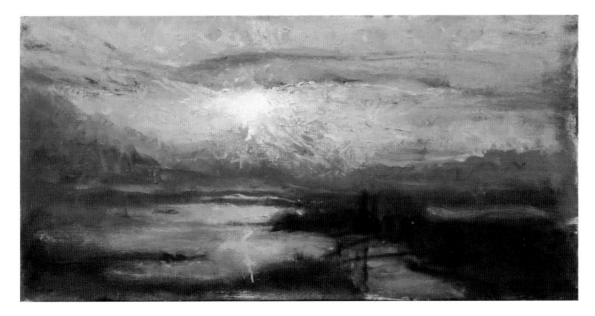

42
Untitled (*New York Bay*), 1998
Oil on canvas
24 ⅛ x 32 inches (61.3 x 81.3 cm)
Collection of Nicholas Katzman, Berlin

43
Glorious Sky, 1998
Oil on canvas
32 x 40 inches (81.3 x 101.6 cm)
Collection of the Katzman family

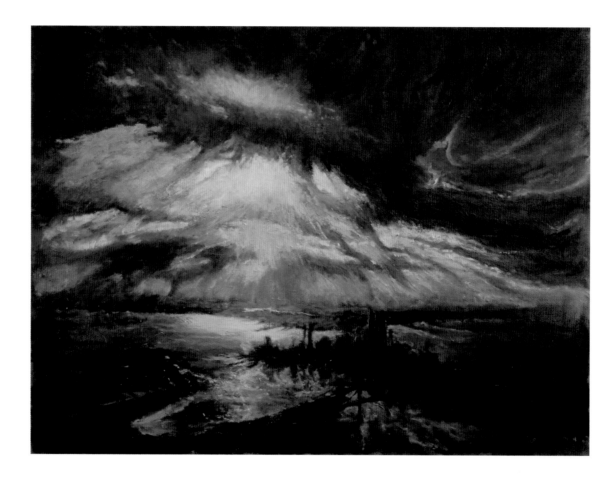

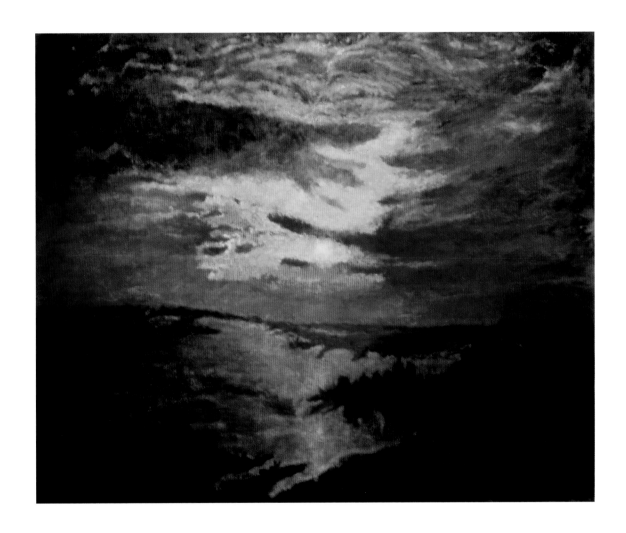

44 (this page, above)
Untitled (*New York Bay*), February 19, 2000
Oil on canvas, mounted on wood
7 ¼ x 12 ¼ inches (18.4 x 31.1 cm)
Collection of the Katzman family

45 (this page, below)
View of the Battery, 1989
Oil on canvas, mounted on wood
5 ½ x 12 ½ inches (14 x 31.8 cm)
Private collection

46 (facing page)
New York Bay, ca. 1995–98
Oil on canvas
23 ¼ x 45 ½ inches (59 x 115.6 cm)
Collection of the Katzman family

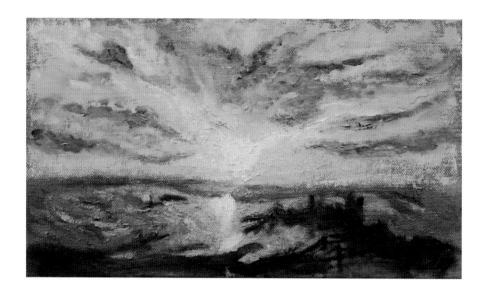

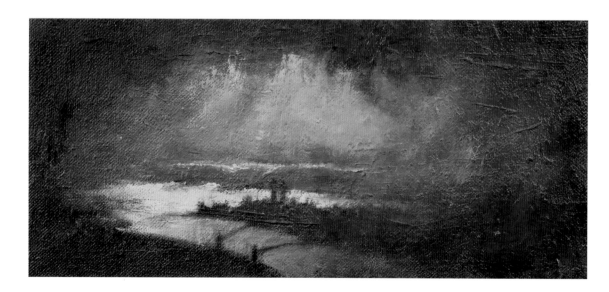

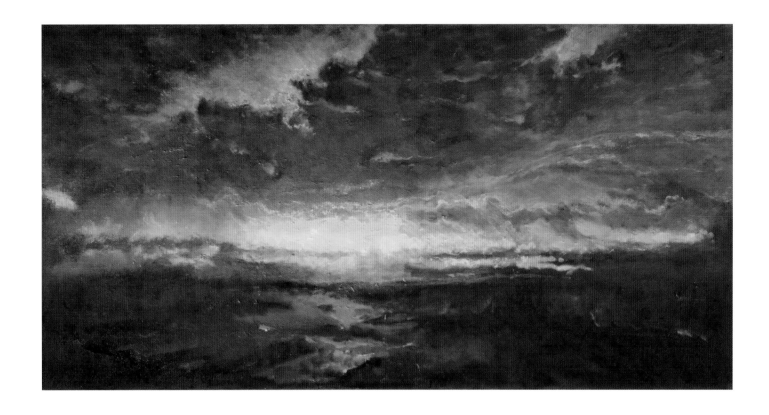

47
New York Bay, 1996
Oil on canvas, mounted on wood
7 ⅞ x 14 ⅞ inches (20 x 36.5 cm)
Collection of Steven Katzman,
San Rafael, California

48
New York Harbor, September 12, 2000
Oil on canvas
12 x 24 inches (30.5 x 61 cm)
Collection of the Katzman family

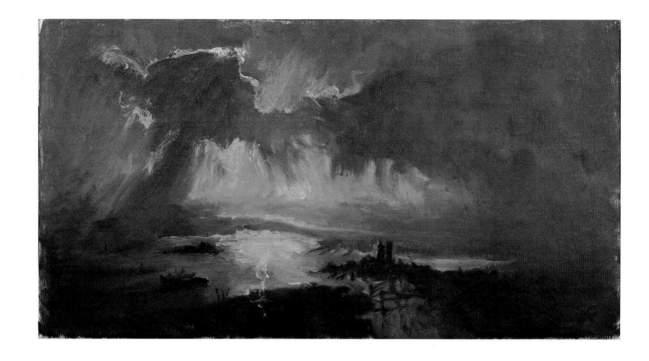

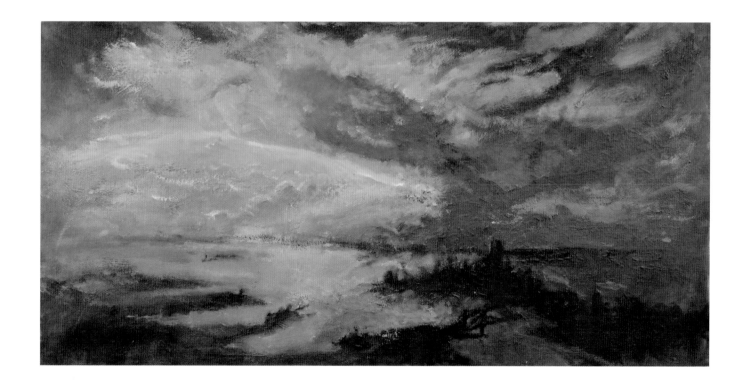

DRAWINGS

49
Self-Portrait, 1973
Sepia chalk on paper
43 ½ x 36 inches (110.5 x 91.4 cm)
National Academy Museum, New York

50
Two Friends at the Met, 1978
Sepia chalk on paper
63 ¹⁄₁₆ x 71 ⅜ inches (160.2 x 181.3 cm)
Daniel and Joanna S. Rose

51
View of New York City, 1976
Sepia chalk on paper
51 x 74 inches (129.5 x 188 cm)
Malcolm Holzman

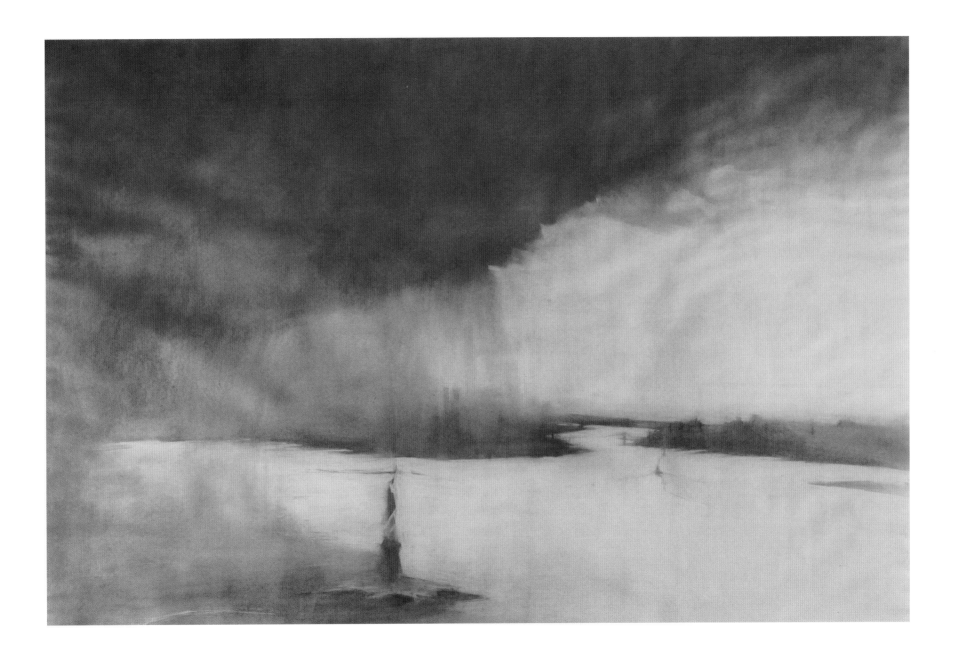

52
New York Bay, 1974
Chalk on paper
29 x 40 inches (73.7 x 101.6 cm)
Palmer Museum of Art of
The Pennsylvania State University,
University Park, Purchased with
matching funds from the National
Endowment for the Arts and The
Pennsylvania State University Office
of Gifts and Endowments

53
East River, 1978–79
Green chalk on gray paper
47 x 75 inches (119.4 x 190.5 cm)
Collection of the Katzman family

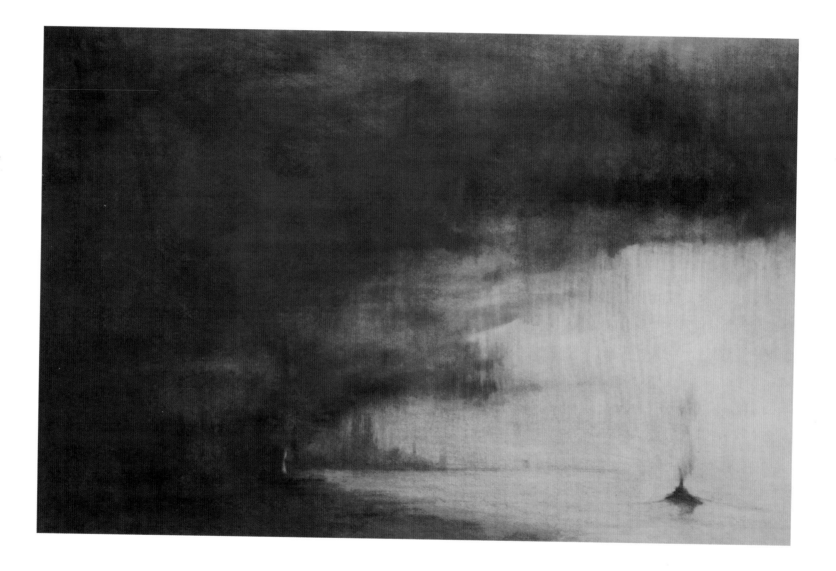

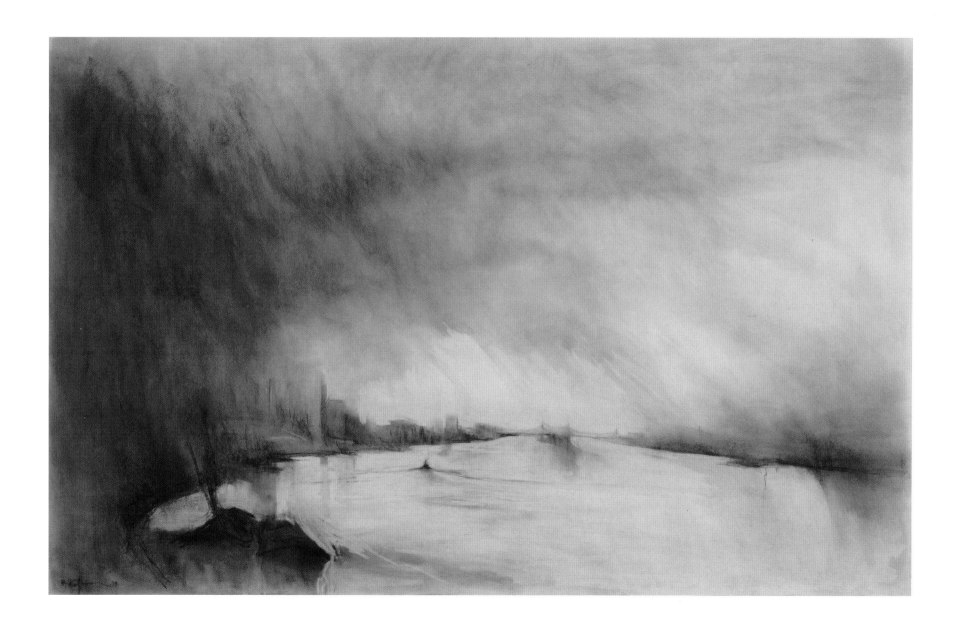

54
Untitled (*New York Bay*), 1989
Sepia chalk on pink paper
22 x 38 5/16 inches (55.9 x 97.3 cm)
Collection of the Katzman family

55
The Battery, 1989
Blue chalk on paper
22 x 39 inches (55.9 x 99 cm)
Ann and Andrew Dintenfass

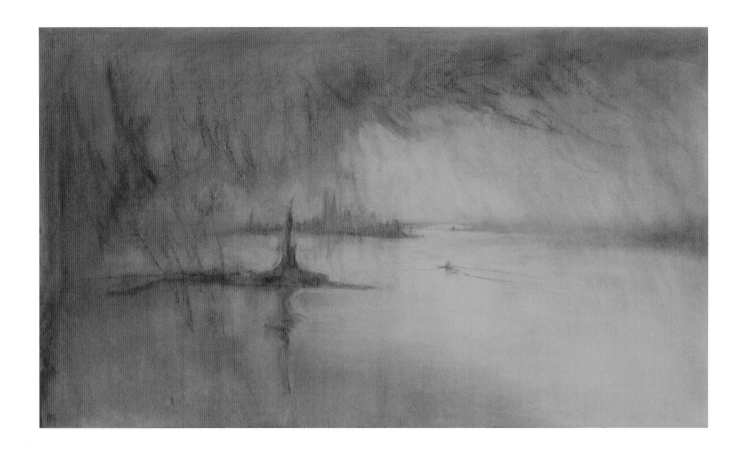

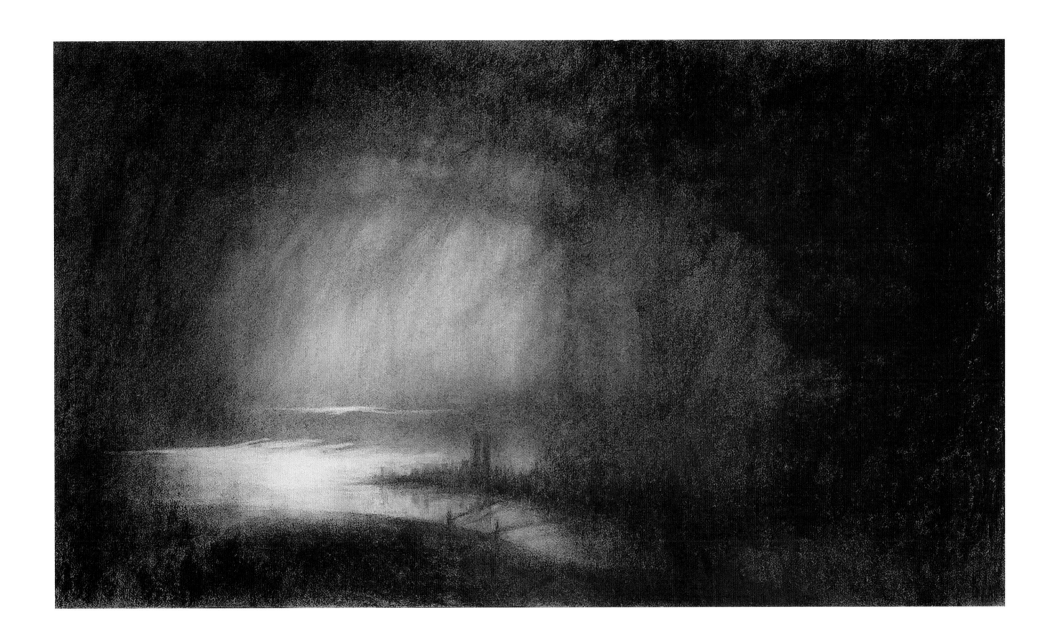

56
Tug Boat in New York Bay, 1979
Chalk on paper
47 x 73 inches (119.4 x 185.4 cm)
E. William Judson, New York

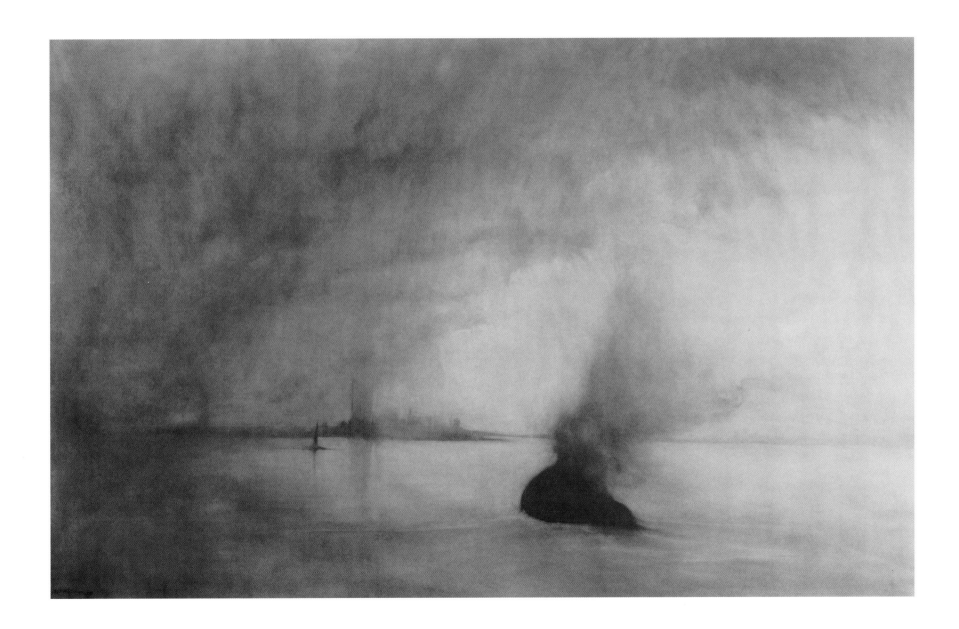

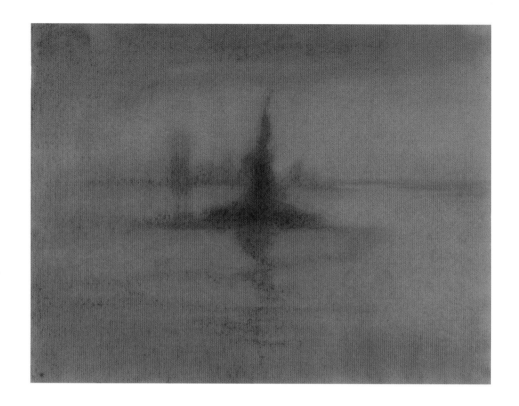

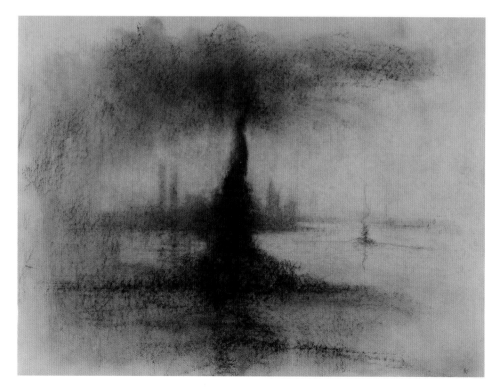

57
Statue of Liberty, 1990
Green chalk on orange paper
20 x 26 inches (50.8 x 66 cm)
Collection of the Katzman family

58
Statue of Liberty, 1991
Green chalk on green paper
20 x 25 inches (50.8 x 63.5 cm)
Collection of the Katzman family

59
Tug Entering New York Bay, 1990
Blue chalk on pink paper
19 ⅞ x 26 ¼ inches (50.5 x 66.7 cm)
Collection of the Katzman family

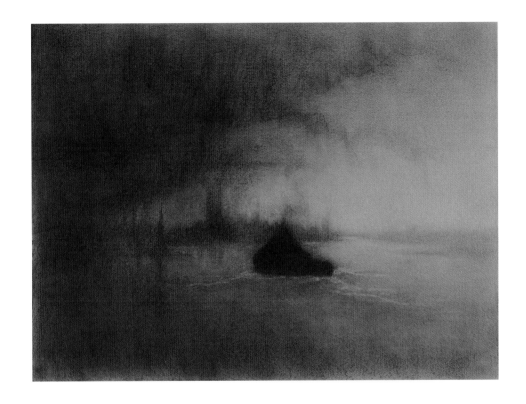

60
Liner Leaving New York Bay, 1990
Blue chalk on blue paper
20 x 26 ¾ inches (50.8 x 67.9 cm)
Collection of Steven Katzman,
San Rafael, California

61
Queensboro Bridge, 1990
Green chalk on yellow paper
20 ¼ x 26 ¾ inches (51.4 x 67.9 cm)
Collection of the Katzman family

62
East River, 1991
Chalk on lavender paper
21 x 26 inches (53.3 x 66 cm)
Collection of the Katzman family

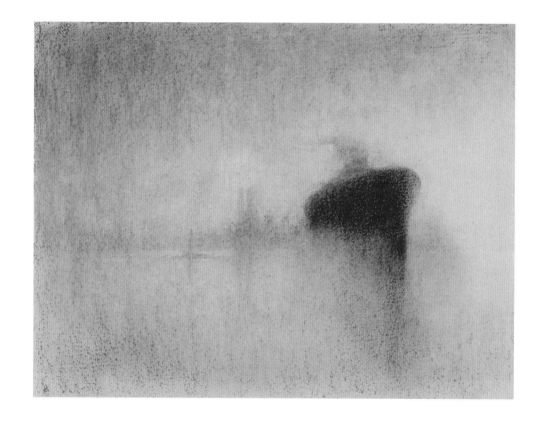

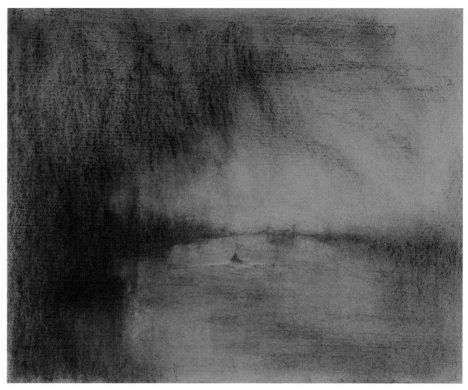

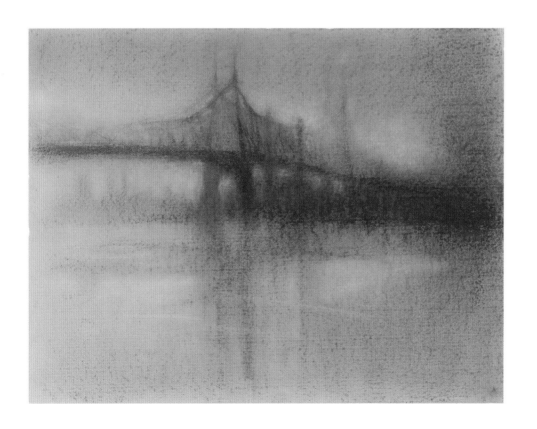

63
Untitled (The Battery), 1995
Green chalk on yellow paper
37 ½ x 75 ½ inches (95.3 x 191.8 cm)
Daniel and Joanna S. Rose

64
Untitled (*View of Manhattan*), 1995
Blue chalk on yellow paper
41 x 81 inches (104.1 x 205.7 cm)
Collection of the Katzman family

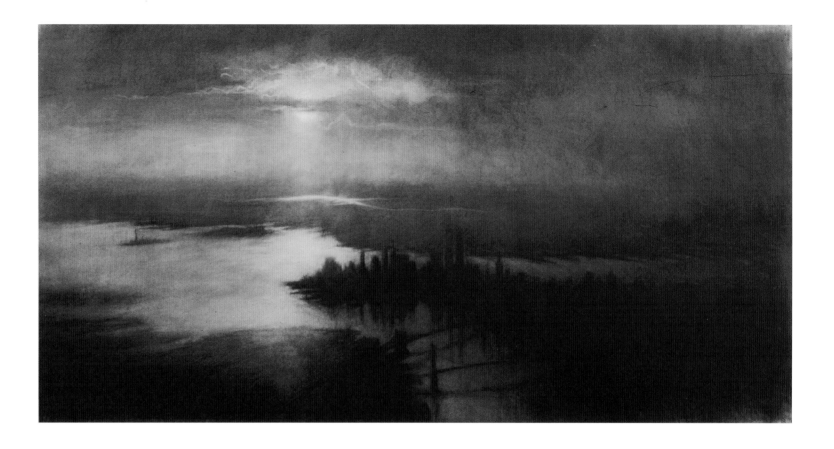

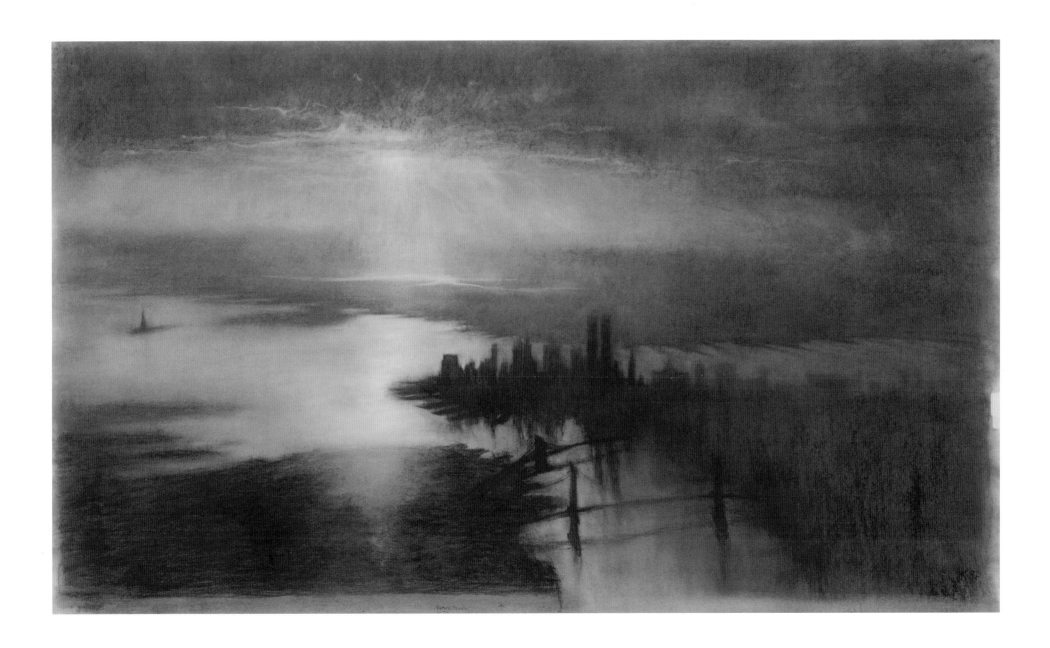

65
Rain—New York Bay, 1992
Chalk on paper
35 x 46 ¼ inches (88.9 x 117.5 cm)
Collection of the Katzman family

66 (facing page, below)
Statue of Liberty, Lightning,
February 20, 2003
Graphite on paper
3 ½ x 8 ⅛ inches (8.9 x 20.6 cm)
Collection of the Katzman Family

67 (facing page, above)
Statue of Liberty–Lightning,
New York Bay, February 20, 2002
Graphite on paper
3 ½ x 7 ¼ inches (8.9 x 18.4 cm)
Collection of Nicholas Katzman, Berlin

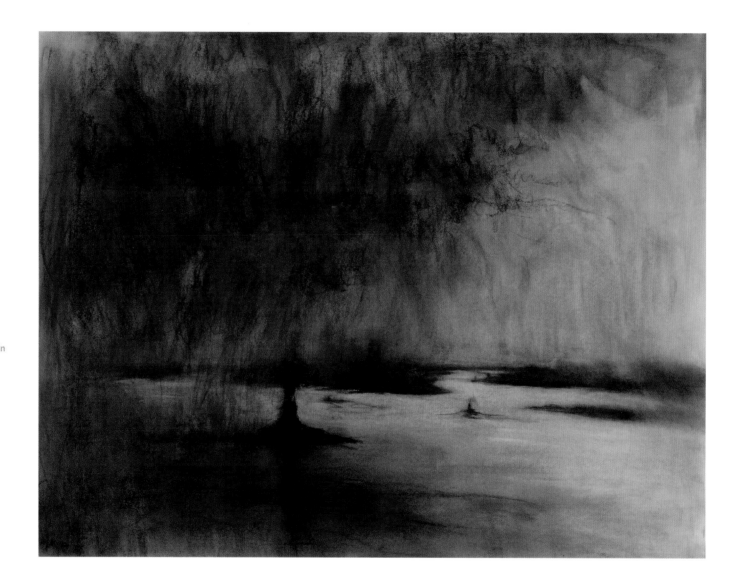

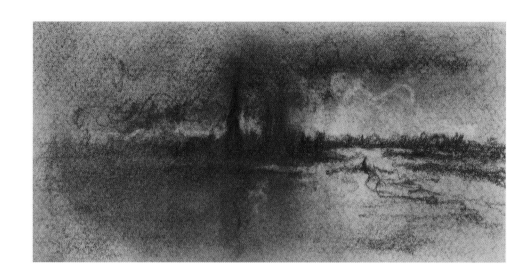

68
Untitled, November 30, 2001
Graphite on paper
5 x 7 ⅜ inches (12.7 x 18.7 cm)
Collection of the Katzman family

69
*Statue of Liberty, New York Bay—
Lightning Storm*, November 25, 2002
Graphite on paper
3 ⅜ x 7 ⅝ inches (19.4 x 8.6 cm)
Collection of Nicholas Katzman, Berlin

70
Untitled (*Statue of Liberty with
Lightning*), 1996
Chalk on paper
50 ⅜ x 78 ³⁄₁₆ inches (128 x 198.6 cm)
Collection of the Katzman family

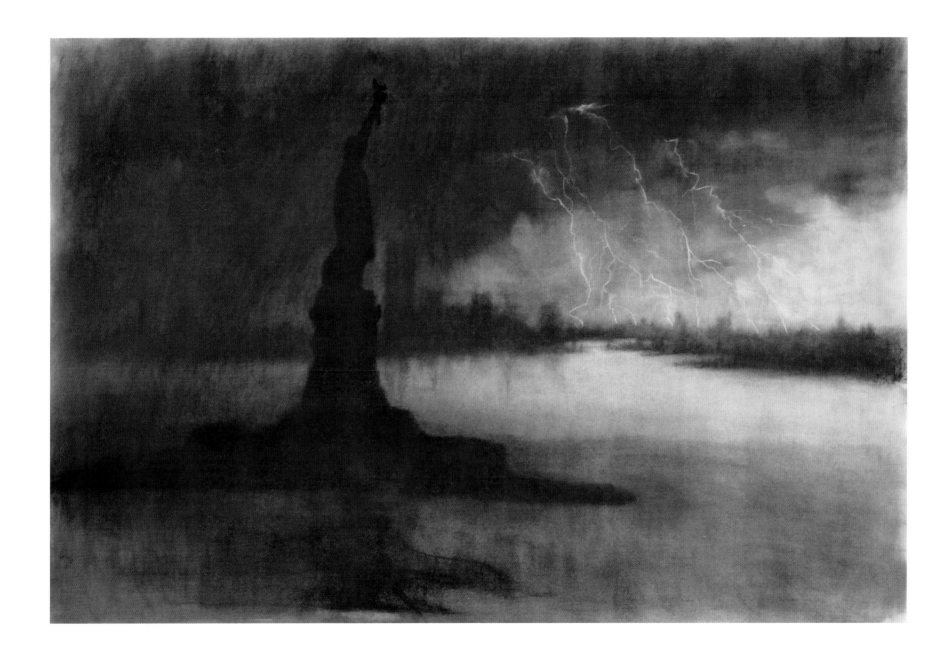

71 (this page, above)
View from the Williamsburg Bridge,
July 7, 2002
Graphite on paper
7 x 4 ⅞ inches (17.8 x 12.4 cm)
Collection of the Katzman family

72 (this page, below)
New York Bay, July 5, 2002
Graphite on paper
2 ½ x 9 ½ inches (6.4 x 24.1 cm)
Collection of Nicholas Katzman, Berlin

73 (facing page)
East River–Williamsburg Bridge, 2003
Graphite on paper
4 ½ x 12 ¾ inches (11.4 x 32.4 cm)
Collection of the Katzman family

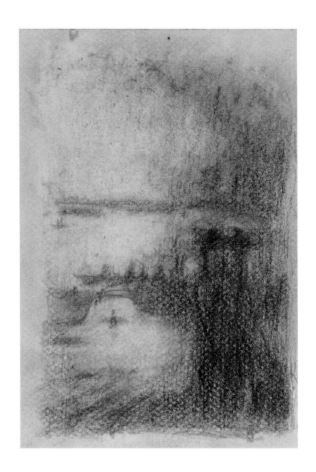

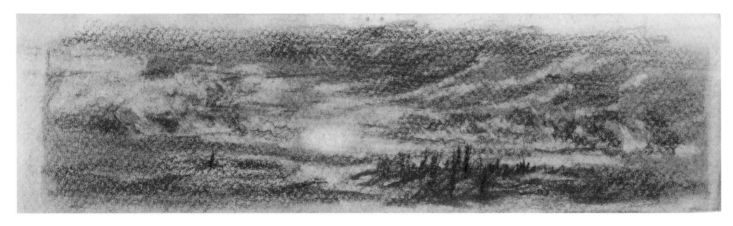

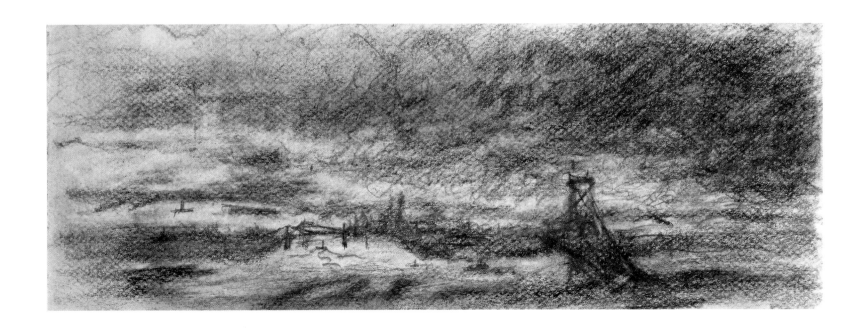

74 (this page, above)
Rain–New York Bay, November 18, 2003
Graphite on paper
7 x 9 inches (17.8 x 22.9 cm)
Collection of the Katzman family

75 (this page, below)
Untitled, ca. 2002–04
Graphite on paper
1 x 3 ¾ inches (2.5 x 9.7 cm)
Collection of the Katzman family

76 (facing page)
East River, 1992
Green chalk on yellow paper
24 ¼ x 51 inches (61.6 x 129.5 cm)
Collection of the Katzman family

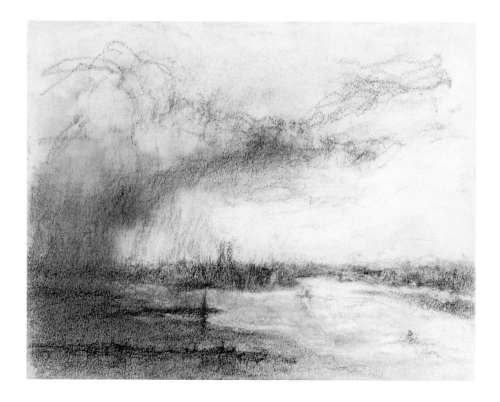

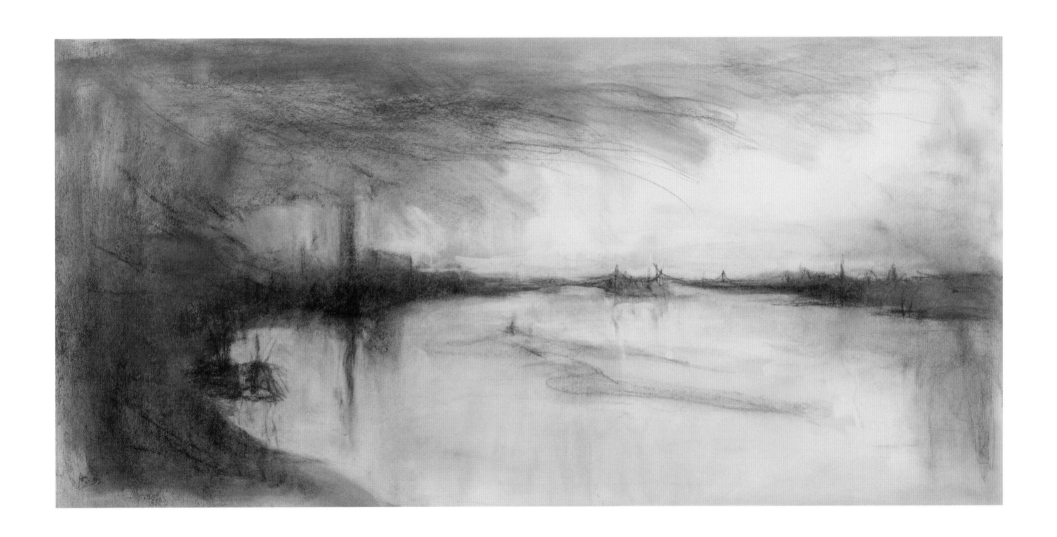

77
Fireworks, Brooklyn Bridge, May 2, 2002
Graphite on paper
3 x 6 ¼ inches (7.6 x 15.9 cm)
Collection of the Katzman Family

78
Queensboro Bridge, April 3, 2003
Graphite on paper
 8 ¼ x 6 ¾ inches (21 x 17.2 cm)
Collection of Nicholas Katzman, Berlin

79
Queensboro Bridge, 1996
Sepia chalk on yellow paper
32 x 58 inches (81.3 x 147.3 cm)
Collection of the Katzman family

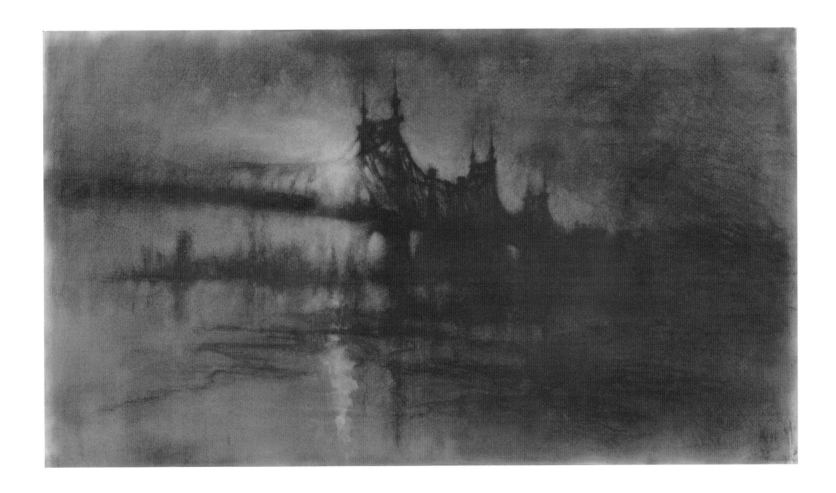

80
New York Bay, August 1, 2002
Graphite on paper
2 x 5 inches (5 x 12.7 cm)
Collection of Nicholas Katzman, Berlin

81
New York Bay, May 7, 2002
Graphite on paper
4 ¾ x 9 inches (12.1 x 22.9 cm)
Collection of Nicholas Katzman, Berlin

82
Lightning Storm—New York Bay,
December 2, 2002
Graphite on paper
3 x 6 ½ inches (7.6 x 16.5 cm)
Collection of Nicholas Katzman, Berlin

83
New York Bay, March 8, 2003
Graphite on colored paper samples
Seven drawings, 3 x 5 inches
(7.6 x 12.7 cm) each
Collection of the Katzman family

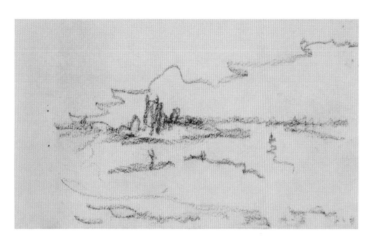

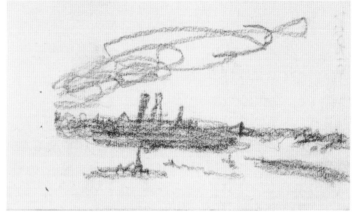

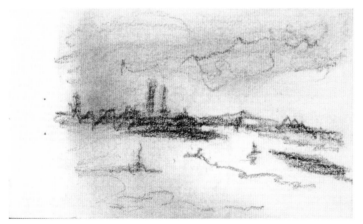

CHRONOLOGY

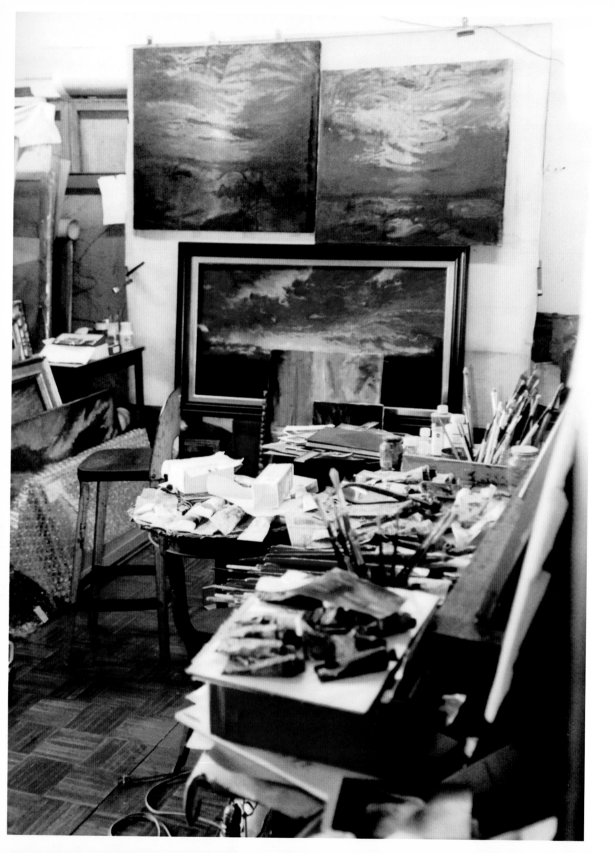

CHRONOLOGY

JILLIAN E. RUSSO

Katzman's studio, Westbeth Artists
Housing, Greenwich Village, New York,
ca. 1998. On wall: above, two versions
of *Glorious Sky* (1998, plate 43); below,
New York Bay (ca. 1995–98, plate 46)

Herbert Henry Katzman was born in Chicago on January 8, 1923, to Louis Katzman, a dentist, and Faye Horowitz Katzman. He and his older bother Robert Katzman (Bob) both had an interest in art and pursued careers in it (fig. 22). When he was nine or ten years old, Katzman's mother took him to Saturday lectures at The Art Institute of Chicago, which inspired his interest in sculpture. Although Faye died when Katzman was 11, he continued studying at The Art Institute. In 1935, he began taking Saturday sculpture classes, but when his teacher encouraged him to make African-style masks he switched into Malcolm Hackett's painting class. Katzman's father did not approve of his son's interest in art and sent him to Chicago's Morgan Park Military Academy (fig. 23). After graduating, he attended Senn High School for one year before his father enrolled him and his brother in St. Johns Military Academy in Delafield, Wisconsin. Katzman nevertheless sketched prolifically during his student years, examining the human body, rendering still lifes, and drawing cartoons. He also attended exhibitions at the Arts Club of Chicago, where he viewed works by André Derain, Paul Klee, and Pablo Picasso.

FIG. 22
Herbert Katzman with his mother
Faye Horowitz Katzman and brother
Bob, ca. 1920s

FIG. 23 (below)
Katzman (top row, third from right) with
Morgan Park Military Academy football
team, Chicago, ca. 1935

FIG. 24 (below left)
Katzman, in Navy uniform, with
his father Louis Katzman, 1942

In 1940, at 17 years of age, Katzman began studying full time at the School of the Art Institute of Chicago, where he was trained in life drawing and painting. His father, who had wanted him to become a doctor, refused to pay the tuition. Katzman financed his education by working as a night janitor at the school and taking other odd jobs. He studied painting under Louis Ritman, who had lived in Paris and had known Amedeo Modigliani and Chaim Soutine (fig. 26). Katzman left the class, however, because Ritman would make "corrections" to Katzman's works by painting directly on his canvases. He then entered Boris Anisfeld's painting class and studied lithography with Francis Chapin. These two instructors provided Katzman with distinct artistic perspectives.

FIG. 25
Katzman in front of his rendition
of George Bellows's 1924 painting
Dempsey and Firpo, ca. 1942–44

FIG. 26
Class photo of Louis Ritman's class,
School of the Art Institute of Chicago,
ca. 1945–47. Katzman and Joan Mitchell
stand at the far left

Born in Bieltsy, in Eastern Europe, Anisfeld developed a style that was influenced by Ukrainian realist painter Ilya Repin and by Symbolism, but also by French Impressionism. Before immigrating to the United States in 1928, Anisfeld had created colorful, fanciful stage designs for Sergei Diaghilev's Ballet Russe productions. Chapin was born in Bristoville, Ohio, and became well-known for his urban scenes and landscape paintings. Around 1940, Katzman met Katherine Kuh, owner of the Katherine Kuh Gallery—a pioneering gallery dedicated to avant-garde art in Chicago. Kuh joined the curatorial department of The Art Institute of Chicago in 1943, and Katzman worked the slide projector during her lectures.

From 1942 to 1944, Katzman served as a Seaman First Class in the Navy with the hopes of being sent to sea, but because he suffered from asthma, he was stationed just one hour outside Chicago (fig. 24). He continued to draw and paint during this time, even producing a large copy of George Bellows's 1924 boxing painting *Dempsey and Firpo* (fig. 25) for the gym at the Navy base. In 1946, he viewed the works of John Constable and Joseph Mallord William Turner in The Art Institute of Chicago's exhibition *Masterpieces of English Painting: Hogarth, Constable and Turner*. That year Katzman graduated from the institute with a certificate in painting and was awarded the John Quincy Adams Foreign Traveling Fellowship, which allowed him to journey abroad. The following year, with additional support from the GI Bill, Katzman moved to Paris. Because the bill required him to attend classes, he enrolled at the Académie de la Grande Chaumière, but attended for only one day. Living in a hotel on rue de Seine, he was introduced to his future wife Judith Baker (Duny) through her sister Lynn (fig. 27). Duny was visiting Lynn, who was studying at the Université Paris Sorbonne. Eighteen at the time, Duny had just graduated from The Dalton School in Manhattan and was also studying art in Paris, pursuing her dream of becoming a painter.

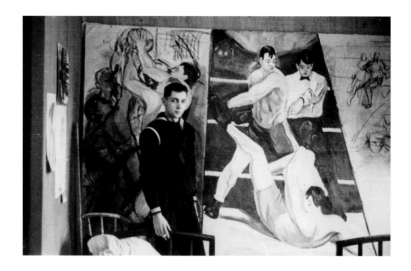

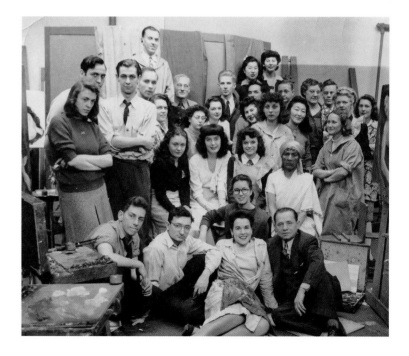

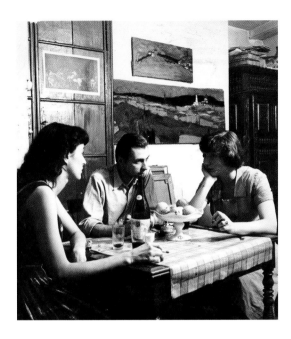

Inspired by a picture of Prague in *Life* magazine, Katzman traveled to Germany and Czechoslovakia with his friend, the artist and amateur cellist Andy Martin. Katzman took photographs and made sketches on the trip, which he used as source material for a series of cityscape paintings, including *View of Prague* (1948, fig. 3), created after he returned to Paris. There he and Duny moved to a top-floor apartment at 73, rue Galande overlooking Notre Dame de Paris. Duny gave up her painting career soon after moving in with him. They were married on Thanksgiving Day, November 26, 1949.

During the 1940s, there was a vibrant expatriate circle of artists, writers, and musicians in Paris. Katzman met American painter Robert Gwathmey, writers James Baldwin and Allan Temko, poet Louis Simpson, and blues and jazz musicians. The Abstract Expressionist painter Joan Mitchell, whom he had met in Ritman's class at The Art Institute of Chicago, lived in the ground-floor apartment of Katzman's building on rue Galande (fig. 29). Katzman made several lifelong friends in Paris, including editor Eric Protter, sculptor Harold Tovish, and Daniel Rose, who was a student at the time, and who later became an ardent collector of Katzman's work. Katzman made his first sale to Rose in 1949.

While living in Paris, Katzman traveled to England, southern France, Italy, the Netherlands, Scotland, and Switzerland (fig. 28). He also decided to go to Belgium with fellow artist Byron Goto to meet Expressionist painter James Ensor, who was living in Ostend. He described the experience of meeting the master as one of the most memorable of his life. He made a sketch of Ensor, which he later turned into portraits of the artist, one of which was a contemplative painting of the artist in front of his masterpiece: *Ensor Seated before "The Entry of Christ into Brussels"* (1985, fig. 20). Throughout his time in Paris, Katzman was productive—painting quickly, vigorously, and with a loaded brush, frequently making one painting per day.

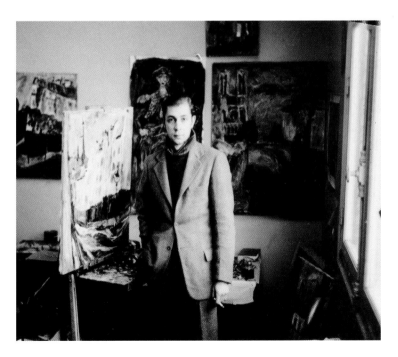

FIG. 27 (above, left)
Katzman and his future wife Duny in front of Notre Dame de Paris, ca. 1947

FIG. 28 (below, left)
Katzman sketching in Venice, 1948

FIG. 29 (above, right)
Duny, Katzman, and Mitchell in Paris, ca. 1947–50

FIG. 30 (below, right)
Katzman in his Paris studio, 1947

FIG. 31
Katzman, Duny, and their son
Nick at the American
Hospital of Paris, May 1950

In 1950, Katzman exhibited at Gallery Huit, a small cooperative gallery located at 8, rue Saint Julien-le-Pauvre, Paris. Established by Haywood Bill Rivers, it became a meeting and exhibition space for expatriate artists, including Sam Francis, Sidney Geist, Burt Hasen, Al Held, Jonah Kinigstein, Jules Olitski, and Shinkichi Tajiri, among others.

In August, several months after his first son Nicholas Robert Katzman (Nick) was born at the American Hospital of Paris on May 29, 1950 (fig. 31), Katzman and his new family returned to the United States on the *SS Stratheden* because he had used up the funds associated with the GI Bill and Adams fellowship. Settling in New York, the family stayed briefly with Duny's mother on Lafayette Street and then moved into a small apartment on St. Marks Place. Katzman got a job in the ceramics factory of the Associated American Artists Group to help support the family. Duny's mother, Ruth Reeves, a textile designer who created carpets and tapestries for Radio City Music Hall and who had directed the New Deal's *Index of American Design* project in the 1930s, introduced him to Edith Halpert, owner of the Downtown Gallery. A progressive art gallery in Greenwich Village that had opened in 1926, the Downtown Gallery was one of the first to promote modern American art, including the work of Ralston Crawford, Stuart Davis, Arthur Dove, Marsden Hartley, Jack Levine, John Marin, Georgia O'Keeffe, Max Weber, William Zorach, and many others. Halpert bought three paintings by Katzman and invited him to join the gallery, supporting him with 100 dollars a month.

In 1951, the Katzmans moved to New City, in Rockland County, New York, and rented Reeves's house at 94 South Mountain Road. They lived in a community of artists and writers who knew each other from the Sunwise Turn Bookshop, an avant-garde bookseller originally located on East 31st Street in Manhattan, which had hosted literary events and sold textiles and sculpture in the 1920s. Actor and playwright Maxwell Anderson lived down the road and the artist Henry Varnum Poor had a

FIG. 32
Katzman in his New York studio,
October 1951

house next door. Katzman earned extra money working in a Rockland ammunition factory making shell casings. In 1951, he exhibited in the *60th Annual American Exhibition* at The Art Institute of Chicago. Katzman's painting *View of Prague* was awarded second place by the judges and he received the Walter M. Campana Memorial Purchase Prize for 1,000 dollars. Willem de Kooning won first prize for his painting *Excavation* (1950, fig. 4). That same year Katzman was awarded a grant from the American Academy of Arts and Letters, New York, and in 1952 he received the J. Henry Scheidt Memorial Prize from the Pennsylvania Academy of Fine Arts, Philadelphia.

In 1952, Alfred Barr, Jr. and Dorothy Miller, director and curator respectively at The Museum of Modern Art, New York, saw his paintings at the Downtown Gallery and invited him to participate in the exhibition *Fifteen Americans*, alongside artists William Baziotes, Edward Corbett, Edwin Dickinson, Herbert Ferber, Joseph Glasco, Frederick Kiesler, Irving Kriesberg, Richard Lippold, Jackson Pollock, Herman Rose, Mark Rothko, Clyfford Still, Bradley Walker Tomlin, and Thomas Wilfred. The exhibition, which included figurative and abstract paintings, as well as sculpture, became renowned for introducing many of the Abstract Expressionists to a large audience.

Although Abstract Expressionism was prominent in the New York art scene, Katzman remained an independent expressionist and rarely patronized the Cedar Bar, a tavern famous for its gatherings of artists. He met de Kooning once, through Protter, who was working on a book with him. Katzman respected de Kooning's work, but continued to look to Old Masters, including Aelbert Cuyp, Claude Lorrain, Rembrandt, Tintoretto, Titian, and Turner. He also admired modern masters such as Pierre Bonnard, Derain (and other Fauve artists), Picasso, and Soutine; American landscape painters such as George Inness and John Frederick Kensett; and American modernists, including Hyman Bloom, Hartley, Edward Hopper, Levine, Alice Neel, and Raphael Soyer.

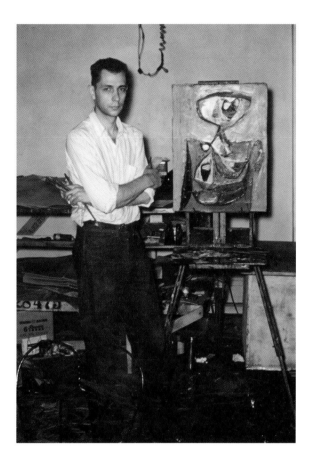

From 1952 to 1953 Katzman taught at the Rockland
Foundation for the Arts in Nyack, New York. His second son
Steven Louis Katzman (Steve) was born on May 21, 1953, at St.
Luke's Hospital in Manhattan. Beginning in 1954, and continuing
until 1960, Katzman exhibited in solo and group shows at
The Alan Gallery. Charles Alan, formerly associated with the
Downtown Gallery, founded The Alan Gallery in fall of 1953 and
showed the work of Robert D'Arista, Louis Guglielmi, William
King, Levine, Nathan Oliveira, and many others.

In 1955, Katzman received a Fulbright grant and moved to Italy
with his family. He lived in a villa located at Via del Casone 27,
at the foot of Bellosguardo, near the Porta Romana in Florence.
He created a series of paintings of the city and small, bronze-cast
figurative sculptures. Katzman's circle of American expatriate art-
ists in Florence included Tovish and figurative painter D'Arista.
His daughter Ann Marie Katzman (Annie) was born at the Irish
Catholic Blue Sisters nursing home in Fiesole on October 27.

In October of 1956, Katzman returned to Manhattan and,
until 1960, lived at 200 West 107th Street at Amsterdam Avenue
in a fifth-floor walk-up apartment with views of the Cathedral
Church of Saint John the Divine. He briefly worked as a window
decorator and a frame maker and then began teaching at Pratt
Institute, Brooklyn. He exhibited in the American Pavilion at
the Venice Biennale in Kuh's exhibition *American Artists Paint the
City*. Examining artists' different responses to billboards, electric
lights, and the dynamism of the modern streetscape, the exhibition
included works by Davis, de Kooning, Hopper, Franz Kline, Jacob
Lawrence, O'Keeffe, Pollock, Charles Sheeler, Joseph Stella, and
Mark Tobey, among others. In 1958, Katzman received an Academy
Award from the American Academy of Arts and Letters.

In 1959, Terry Dintenfass opened her Manhattan gallery at
18 East 67th Street. Katzman was one of the initial five artists, all
of whom were working figuratively, whom she represented. Also
included were Philip Evergood, graphic artist Antonio Frasconi,

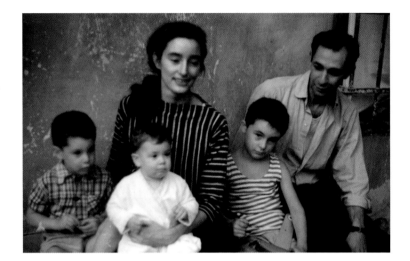

Sidney Goodman, and Gwathmey. Katzman continued to show with the gallery through 1993, even after it moved in 1975 to 50 West 57th Street.

FIG. 34
Katzman in his studio on
Martha's Vineyard, ca. 1964–67

In 1960, Katzman began teaching painting and drawing at the School of Visual Arts in New York (fig. 38). His fellow teachers included Lester Johnson and James Kearns. As a professor, Katzman did not believe in imposing his artistic methods on his students and developed an informal teaching style in which he served as an artistic presence in the classroom and provided individual commentary on each student's work. That same year he delivered a lecture on painting, teaching, and the art world to artists in residence at the summer program at the Skowhegan School of Painting and Sculpture, which had been founded by Poor, along with several other artists, in Skowhegan, Maine. Also during that summer, Katzman moved to 258 Riverside Drive at 98th Street, where his friends, writer George Mandel and painter Robert Kulicke, also had apartments.

In the mid-1960s, Katzman moved his studio to Broadway and 103rd Street. Around this time, he began creating a series of paintings of New York waterways, such as *East River* (1965, plate 4) and *New York Harbor* (1967, plate 8), using soft, translucent gray tonalities to capture the atmospheric effects of rain and clouds moving over the water. In these works, the dissolution of river and sky into an arrangement of form and color evokes James Abbott McNeill Whistler. Prior to this move, Katzman's studio had been located downtown, near Union Square.

From 1966 to 1967, Katzman accepted a position as a visiting faculty member for two semesters at the University of Iowa, Iowa City, where he taught drawing. Well respected by the students, he encouraged them to examine the movements and flow of the body. After returning to New York, he began creating large-scale drawings. In 1967, he was commissioned to create a painting for

an advertisement for De Beers diamonds, which appeared in magazines such as *Look* and *Life*. The painting depicts Duny and their son Nick in a rowboat on Tisbury Great Pond on Martha's Vineyard, Massachusetts, where the family vacationed regularly from 1964 through 1967 (fig. 34). For the first three years the family stayed at Fred Fisher's house, which artist Wolf Kahn often rented, on Lambert's Cove in West Tisbury. Katzman received two major awards in 1966 and 1968—a grant from the National Council on the Arts and a John Simon Guggenheim Memorial Foundation Fellowship, respectively.

In the fall of 1969, Katzman and Duny divorced. He moved to an apartment in Hell's Kitchen on Eighth Avenue and 51st Street. Two years later, he moved his studio to Westbeth Artists Housing at 55 Bethune Street in Greenwich Village, which had opened the previous year. In 1973, he created a contemplative portrait of himself seated. This large-scale drawing would become his 1976 admission piece to become an Associate Member of the National Academy of Design, New York, an association of American artists founded in 1825 by Samuel F. B. Morse, Asher B. Durand, and Thomas Cole, among others. He submitted *Portrait of Raphael Soyer* (1973), which pictured the artist at his easel with brush in hand, to the National Academy when he became a full member in 1984. From 1972 to 1976, Katzman received grants from the now-defunct Creative Artists Public Service Program (CAPS) of the New York State Council on the Arts. In 1979, he met the woman who was to become his second wife: Laurel Carroll, an artist and a model at the School of Visual Arts. That year they traveled to Florence, Milan, and Venice.

Throughout the 1980s, Katzman created a series of portraits of family members and renowned artists, as well as self-portraits. He painted Anisfeld in *Boris Anisfeld Holding Essie* (ca. 1982–83) and various influential American artists in the works *Portrait of Robert Gwathmey* (1983) and *Marsden Hartley Standing before "Portrait of a German Officer"* (1983), as well as in *Tovish* (1981). The portrait of Hartley was inspired by a photograph of the artist from *Life* magazine that his friend Kearns had given him. In 1984, Katzman was elected to full membership of the National Academy of Design. The following year he married Carroll on October 25. She was the subject of several portraits, including *Interior with Laurel* (ca. 1983–84, fig. 39) and *Laurel Reading* (1985). Also in 1985, Katzman was honored with a retrospective exhibition organized by the Artists' Choice Museum, New York, curated by his former student, Steve Sherman. Two years later he received the Benjamin Altman Prize from the National Academy of Design.

Around 1986, Katzman left his teaching post at the School of Visual Arts. For years his interests as a master draftsman and expressionist painter had gradually been falling out of step with the direction of the institution, which was engaged with the developments of the contemporary art scene propelled by New York galleries and commercial art and design. Over the course of his lengthy teaching career, Katzman was influential in the development of figurative artists such as Bill Murphy, Don Perlis, Sherman, and Sarah Yuster. In 1989, he was hospitalized with an asthma attack and diagnosed with emphysema.

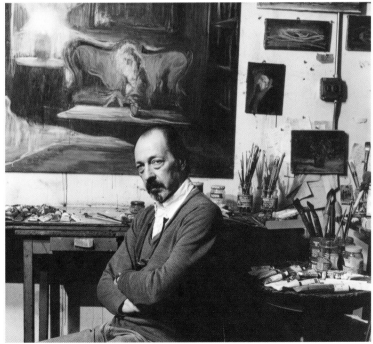

Throughout the 1990s, Katzman focused on drawings and small paintings. He drew New York Bay, tugs moving through New York Harbor, the East River, the Queensboro Bridge, and the Statue of Liberty, often focusing on capturing atmospheric effects using black or colored chalk on various colored papers, from white and gray to more vivid oranges and greens. He created a series

FIG. 40
Katzman and his daughter
Annie in the kitchen at Westbeth
Artists Housing in front of Katzman's
salon-style installation of his small
paintings, 2004

of painterly views of New York Bay with dramatic and colorful sunsets, lightning, and gathering rain clouds. His paintings depicting the Brooklyn Bridge, Queensboro Bridge, and the Statue of Liberty feature vivid celestial effects such as bright yellow skies, rainbows, and fireworks, among them *Glorious Sky* (1998, plate 43). In 1994, Katzman and Carroll separated and several years later divorced. In October 1998, Katzman developed pneumonia and was hospitalized for two months.

After the devastation of September 11, 2001, an event visible from the windows of his studio at Westbeth, Katzman's emphysema, exacerbated by years of smoking and, as his family believes, the dust from the destruction of the World Trade Center towers, worsened into a serious bronchial infection. He was hospitalized again in December 2001 and January 2002. As a result he could no longer work in oil, charcoal, or pastel. Unable to leave the studio, and hardly able to walk, he worked primarily in his kitchen, his walls covered, salon-style, with his paintings and drawings, which served as inspiration. Despite his chronic illness, Katzman continued to draw prolifically and won a Lee Krasner Award, renewable for three years, from the Pollock-Krasner Foundation in 2000. Working mostly from memory, he began a series of miniature graphite drawings that recall his paintings and drawings of New York, but on a much more intimate scale. Katzman died in his studio on October 15, 2004, with a drawing of the New York Harbor on the table in front of him.

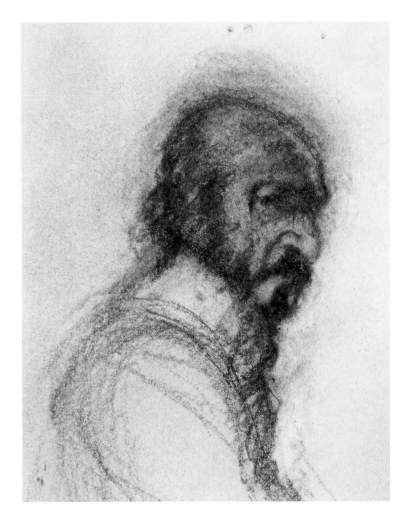

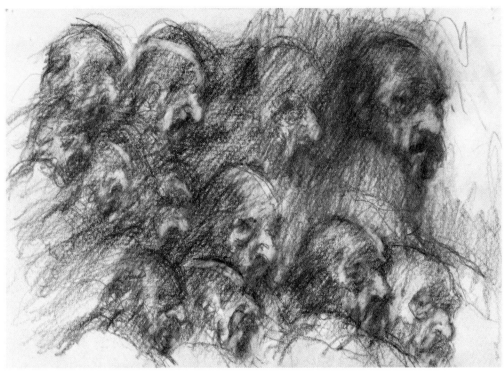

FIGS. 41, 42
Herbert Katzman
Self-Portrait, October 27–
November 2, 2002
Graphite on paper
4 ¼ x 3 ¾ inches (10.8 x 9.5 cm)
Collection of the Katzman family

Self-Portraits, October 11, 2002
Graphite on paper
6 x 9 inches (15.2 x 22.9 cm)
Collection of the Katzman family

SOURCES AND SKETCHES

When executing his cityscapes, Katzman did not work on-site; rather, he often worked from other visual prompts. His source materials ranged from vintage photographs and newspaper and magazine clippings to postcards, especially those that captured the aerial views of New York harbor that he favored throughout his career. While some of his images were so entrenched in his memory that no source image was required, at times Katzman used several sources in the making of a single painting or large-scale drawing. He never directly reproduced these materials in the final work of art.

It was Katzman's habit not to waste a single piece of paper. He often recycled used envelopes or grocery store flyers as supports for tiny sketches, and scrap cardboard, for example from cereal boxes, sometimes became mounts for his source imagery.

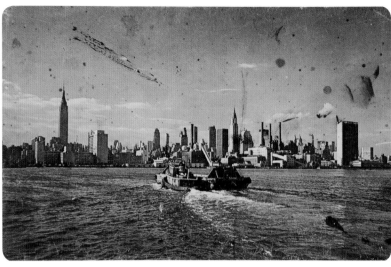

FIG. 43

FIG. 44

FIG. 45

FIG. 46

FIG. 47

FIG. 43
New York skyline and midtown
Manhattan as viewed from the East River
Vintage postcard with paint splatter
and tape

FIG. 44
Downtown Manhattan skyline
showing the Twin Towers
Magazine clipping taped to cereal box

FIG. 45
East River and Queensboro Bridge
Photomontage with artist's sketch,
fingerprints, paint splatter, and tape

FIG. 46
Aerial view of the Brooklyn Bridge
and the downtown Manhattan skyline
Vintage postcard

FIG. 47
East side of Manhattan, East River,
and the Queensboro Bridge
Vintage photograph

FIG. 48
Manhattan skyline at sunset
Magazine clipping pasted on two pieces
of Terry Dintenfass stationery

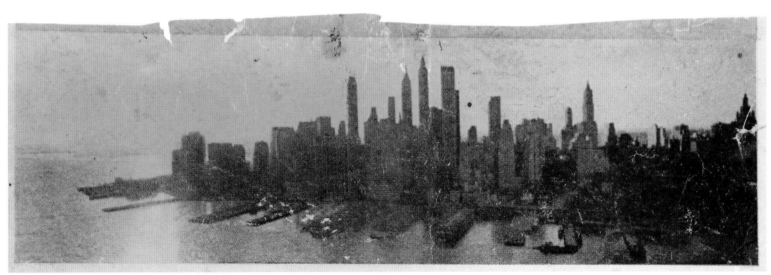

FIG. 48

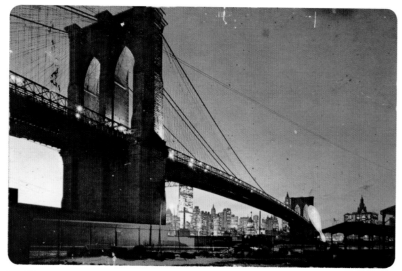

FIG. 49

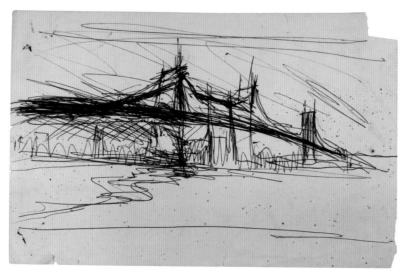

FIG. 50

"QUEENSBORO BRIDGE"—ETCHING BY AMERICAN ARTIST DONALD STOLTENBERG

FIG. 51

FIG. 52

FIG. 53

FIG. 54

FIG. 55

FIG. 56

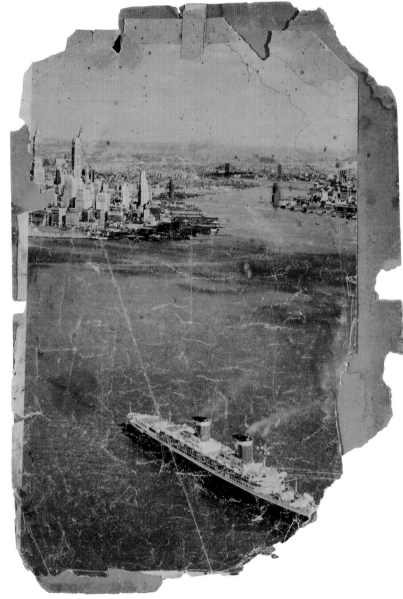

FIG. 57

FIG. 58

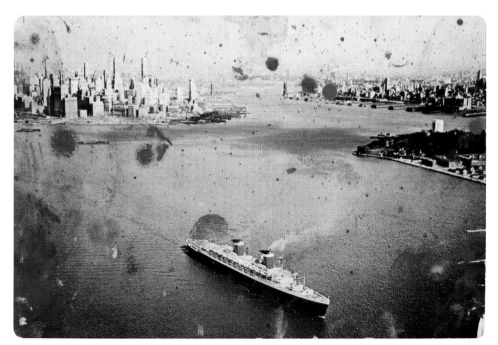

FIG. 59

FIG. 60

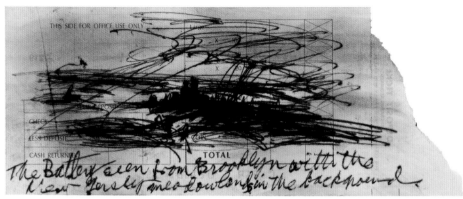

FIG. 61

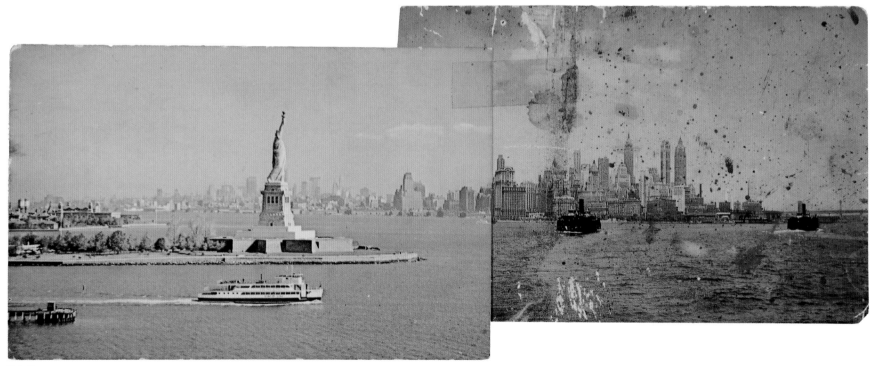

FIG. 62

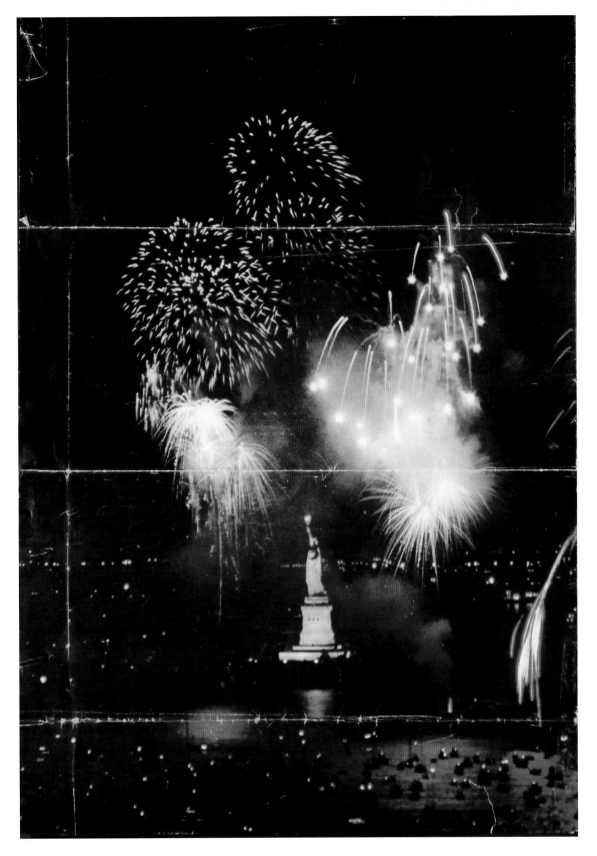

FIG. 60
Herbert Katzman
Manhattan skyline as seen from
New York harbor, date unknown
Ballpoint pen and paint on paper

FIG. 61
Herbert Katzman
Sketch, date unknown
Ballpoint pen on Chase Manhattan
Bank carbon deposit slip. Inscribed: *The
Battery seen from Brooklyn with the New
Jersey meadowlands in the background*

FIG. 62
Statue of Liberty and Manhattan
skyline as viewed from New York harbor
Postcard collage with tape

FIG. 63
Jerome Brent photograph of the
Statue of Liberty with fireworks
Clipping from "The Year in Pictures,"
Life magazine, Winter 1977

FIG. 63

FIGS. 64–69
Annie Katzman
Clouds, Manhattan waterways,
and skyline, 1993–2001
Photomontages

EXHIBITION HISTORY AND SELECTED REVIEWS

SOLO EXHIBITIONS

1954

The Alan Gallery, New York, *Herbert Katzman: New Paintings*, October 5–23. Exh. brochure with text by John I. H. Baur taken from Winter 1954 issue of *Art in America*.

- Coates, Robert M. "Fast Start." The Art Galleries, *The New Yorker*, October 16, pp. 74–77.
- Faison, S. Lane, Jr. "Art." *The Nation* (New York), October 23.

1957

The Alan Gallery, New York, *Herbert Katzman*, February 11–March 2.

- P[arker], T[yler]. "Herbert Katzman." *Art News* (New York) 56, no. 1 (March): p. 13.
- Y[oung], V[ernon]. "Herbert Katzman." In the Galleries, *Arts* (New York) 31, no. 6 (March): p. 55.

1959

The Alan Gallery, New York, *Herbert Katzman: Modern Paintings, Drawings, Sculpture, Collages*, November 9–28. Exh. brochure.

- "Herbert Katzman." *Herald Tribune*, November 5.
- B[urckhardt], E[dith]. "Herbert Katzman." *Art News* (New York) 58, no. 9 (December): pp. 19–20.
- T[illim], S[idney]. "Herbert Katzman." In the Galleries, *Arts* (New York) 34, no. 4 (January 1960): p. 52.

1962

Terry Dintenfass, New York, *Herbert Katzman*, February 5–March 3. Exh. brochure.

- O'Doherty, Brian. "Art: A Regionalism of Intense Reality." *The New York Times*, February 6.

1964

Terry Dintenfass, New York, *Herbert Katzman*, February 4–29. Exh. brochure.

1966

Terry Dintenfass, New York, *Herbert Katzman: Paintings*, February 22–March 12.

- T[ucker], M[arcia]. "Herbert Katzman." Reviews and Previews, *Art News* (New York) 65, no. 1 (March): p. 16.

1967

Terry Dintenfass, New York, *Herbert Katzman: Recent Drawings*, March 7–April 1.

- G., J. "Katzman." *World Journal Tribune*, March 10.
- D[ownes], R[ackstraw]. "Herbert Katzman." *Art News* (New York) 66, no. 2 (April): p. 13.

1968

Terry Dintenfass, New York, *Katzman: Recent Paintings and Drawings*, March 26–April 13.

- B., J. "Herbert Katzman." In the Galleries, *Arts Magazine* (New York) 42, no. 6 (April): p. 62.
- B[enedikt], M[ichael]. "Herbert Katzman." *Art News* (New York) 67, no. 3 (May): p. 16.

1971

Terry Dintenfass, New York, *New Paintings and Drawings by Herbert Katzman*, April 10–May 1.

- Canaday, John. "Robert Andrew Parker and Herbert Katzman." *The New York Times*, April 17.

1975

Terry Dintenfass, New York, *Herbert Katzman: Drawings 1935–1975*, December 30, 1975–January 31, 1976.

- Russell, John. "Herbert Katzman: Drawings 1935–75." *The New York Times*, January 3, 1976.
- "Herbert Katzman." Art, Goings on About Town, *The New Yorker*, January 26, 1976, p. 8.
- Spieler, F. Joseph. "Katzman: Virtuoso Draftsman." *Soho Weekly News* (New York), January 29, 1976.

1978

Terry Dintenfass, New York, *Katzman: Paintings–Drawings*, March 25–April 14.

- Anderson. "Herbert Katzman." *Village Voice*, April 10.

1980

Andrews Gallery, College of William and Mary, Williamsburg, Virginia, *Herbert Katzman: Drawings*, November 17–December 12.

1981

Terry Dintenfass, New York, *Herbert Katzman: Large Drawings*, October 17–November 5.

- Gallati, Barbara. "Herbert Katzman." *Arts Magazine* (New York) 56, no. 5 (January 1982): p. 18.

1985

Artists' Choice Museum, New York, *Herbert Katzman: Retrospective Paintings and Drawings*, September 24–November 3. Exh. cat. with texts by Eloise Segal, Steve Sherman, and Harold Tovish, among others. Insert to catalogue, "Interview with Herbert Katzman," by Janice Becker.

- Sherman, Steve. "Herbert Katzman Retrospective." *ACM: The Journal of the Artists' Choice Museum* (New York) 5, no. 1 (Fall 1985–Winter 1986): pp. 11–12.

1988

Terry Dintenfass, New York, *Herbert Katzman*, April 5–31.

1990

Terry Dintenfass, New York, *Herbert Katzman: Paintings and Drawings*, March 7–31.

1993

Terry Dintenfass, New York, *Herbert Katzman: Drawings*, November 9–December 4. Traveled to: The Butler Institute of American Art, Youngstown, Ohio, February 13–April 2, 1994. Exh. cat. with texts by Terry Dintenfass and Garrit Henry.

- Blustain, Rachel. "Internal Landscapes: Herbert Katzman Sketches Portraits of Emotion." *Forward* (New York), November 26.
- Rubinstein, Raphael. "Herbert Katzman at Terry Dintenfass." *Art in America* (New York) 82, no. 5 (May 1994): p. 116.

GROUP EXHIBITIONS

1948

Pershing Hall, Paris, *Art Exhibition of American Veterans in Paris*, January 24–31. Exh. brochure with texts by E. Othon Friesz and O[ssip] Zadkine.

1950

Galerie Huit, Paris, *Galerie 8 Première Exposition*, June 2–15.

1951

Downtown Gallery, New York, *Newcomers: First Showing of a New Generation*, May 1–19. Exh. brochure.

- Hess, Thomas B. "Young Midwest Painters." *Art News* (New York) 50, no. 3 (May): p. 57.
- Coates, Robert M. "Young Contemporaries and Old Masters," The Art Galleries, *The New Yorker*, May 12, pp. 89–91.

The Art Institute of Chicago, *60th Annual American Exhibition: Paintings and Sculpture*, October 25–December 16. Exh. cat.

- Bulliet, C. J. "Chicago Invites and Rewards Abstract Art." *The Art Digest* (New York) 26, no. 4 (November 15): pp. 8, 34.
- ———. "Indignation in Chicago." *The Art Digest* (New York) 26, no. 4 (November 15): p. 8.
- Jewett, Eleanor. "60th Exhibit in Art Institute Features Fads." *Chicago Daily Tribune*, part 3, October 24.
- Louchheim, Aline B. "Conclusions from a Chicago Annual: Validity and Diversity of Our Art Upheld in Invited Show." *The New York Times*, October 28.

Downtown Gallery, New York, *Opening of The Ground Floor Gallery*, November 6– unknown closing date. Exh. brochure.

Whitney Museum of American Art, New York, *1951 Annual Exhibition of Contemporary American Painting*, November 8, 1951– January 6, 1952. Exh. cat. with foreword by Hermon More.

1952

Downtown Gallery, New York, *Recent Arrivals: Downtown Gallery*, March 4–22.

• Devree, Howard. "Modern Angles: New Shows that Reflect Contemporary Quest." *The New York Times*, March 9.

• "New Crop of Painting Protégés: Dealer with an Eye for Talent Tries to Pick Tomorrow's Stars." *Life*, March 17, pp. 87–88, 91.

The Museum of Modern Art, New York, *Fifteen Americans*, April 9–July 27. Exh. cat. edited and with foreword by Dorothy C. Miller and statements by the artists and others.

• Hess, Thomas B. "The Modern Museum's Fifteen: Where U.S. Extremes Meet." *Art News* (New York) 51, no. 2 (April): pp. 16–19, 65–66.

• Devree, Howard. "Modern Museum has Varied Show: 'Fifteen Americans' Paintings and Sculpture, Will Open to the Public Tomorrow." *The New York Times*, April 9.

• Chanin, A. L. "Art Styles Clash and Clang In Show of 'Fifteen Americans.'" *The World of Art*, *The Compass* (New York), April 13. [In the review Katzman is erroneously referred to as Irving Kriesberg.]

• Devree, Howard. "Diverse Americans: Fifteen in Museum of Modern Art Show—New Work by Nordfeldt and Laurent." *The New York Times*, April 13.

• Genauer, Emily. "Exhibits of Church Art, da Vinci Inventions, Modern Museum Choices." Art and Artists, *New York Herald Tribune*, sec. 4, April 13.

• Fitzsimmons, James. "Fifteen More Questions Posed at the Modern Museum." *The Art Digest* (New York) 26, no. 15 (May 1): pp. 11, 24.

• Coates, Robert M. "Seventeen Men." The Art Galleries, *The New Yorker*, May 3, pp. 95–97.

• Faison, S. Lane, Jr. "Art." *The Nation* (New York), May 10, pp. 457–59.

Downtown Gallery, New York, *2nd Annual Exhibition*, October 14–November 15. Exh. brochure.

Carnegie Institute, Pittsburgh, Pennsylvania, *The 1952 Pittsburgh International Exhibition of Contemporary Painting*, October 16–December 14. Exh. cat.

Whitney Museum of American Art, New York, *1952 Annual Exhibition of Contemporary American Painting*, November 6, 1952–January 4, 1953. Exh. cat. with foreword by Hermon More.

1953

The Pennsylvania Academy of the Fine Arts, Philadelphia, *The One Hundred and Forty-eighth Annual Exhibition of Painting and Sculpture*, January 25–March 1. Exh. cat.

• Devree, Howard. "Two in Contrast: The Quiet Marquet, the Dynamic Corinth at Their Best—Pennsylvania Annual." *The New York Times*, January 25.

• G[oodnough], R[obert]. "One Hundred and Forty-eighth Annual." *Art News* (New York) 52, no. 10 (March): p. 38.

Downtown Gallery, New York, *Celebrating the Tercentenary of the City of New York: Paintings of New York by Leading American Artists*, February 17–March 7. Exh. brochure.

Downtown Gallery, New York, *Eight Younger Artists*, May 12–29. Exh. brochure.

• B., C. Review of *Eight Younger Artists*. Art Notes, *New York Herald Tribune*, sec. 4, May 17.

Whitney Museum of American Art, New York, *1953 Annual Exhibition of Contemporary American Painting*, October 15–December 6. Exh. cat. with foreword by Hermon More.

• Devree, Howard. "Yesterday and Today: Acquisitions at Whitney—Robinson Collection." *The New York Times*, March 8.

1954

Downtown Gallery, New York, *International Exhibition: American, Belgian, British, Canadian, French, Italian, Mexican Painters Under 40*, February 2–27.

• Coates, Robert M. "American and International." The Art Galleries, *The New Yorker*, February 20, pp. 81–83.

The Alan Gallery, New York, *Opening Exhibition, 1954–1955*, September 9–October 2. Exh. brochure.

Downtown Gallery, New York, *29th Annual Exhibition*, October 5–30. Exh. brochure.

• P., S. "About Art and Artists: 29th Show." *The New York Times*, October 8.

Whitney Museum of American Art, New York, *Opening Exhibition, Selections from the Permanent Collection*, October 22–November 14.

• Devree, Howard. "About Art and Artists: New Whitney Retains Intimacy and Warmth and Enhances Displays." *The New York Times*, October 26.

• "The Whitney Museum in its New Home." *The New York Times*, October 31.

Whitney Museum of American Art, New York, *Roy and Marie Neuberger Collection: Modern American Painting and Sculpture*, November 17–December 19. Traveled to: The Arts Club of Chicago, January 4–30, 1955; Art Gallery of the University of California, February 21–April 3, 1955; The San Francisco Museum of Art, April 26–June 5, 1955; The City Art Museum of St. Louis, June 27–August 7, 1955; and The Cincinnati Art Museum, August 29–September 25, 1955. Exh. cat. with foreword by John I. H. Baur and introduction by Marie and Roy Neuberger.

1955

Munson-Williams-Proctor Institute, Utica, New York, *Italy Rediscovered: An Exhibition of Work by American Painters in Italy since World War II*, March 6–27. Exh. cat. with introduction by Harris K. Prior.

Whitney Museum of American Art, New York, *The New Decade: 35 American Painters and Sculptors*, May 11–August 7.

Traveled to: The San Francisco Museum of Art, October 6–November 6; Art Galleries, University of California, Los Angeles, November 20, 1955–January 7, 1956; Colorado Springs Fine Arts Center, February 9–March 20, 1956; and The City Art Museum of St. Louis, April 15–May 15, 1956. Exh. cat. edited by John I. H. Baur and research by Rosalind Irvine.

• Coates, Robert M. "The Grand Tour." The Art Galleries, *The New Yorker*, May 28, pp. 98–102.

Shapiro Athletic Center, Brandeis University, Waltham, Massachusetts, *Three Collections: An Exhibition*, June 1–17. Exh. cat. with text by Mitchell Siporin.

Carnegie Institute, Pittsburgh, Pennsylvania, *The 1955 Pittsburgh International Exhibition of Contemporary Painting*, October 13–December 18. Exh. cat.

Whitney Museum of American Art, New York, *1955 Annual Exhibition of Contemporary American Painting*, November 9, 1955–January 8, 1956. Exh. cat.

1956

Tweed Gallery, University of Minnesota Duluth, *Collector's Choice*, April 1–30.

American Pavilion, 28th Venice Biennale, *American Artists Paint the City*, June–August. The Art Institute of Chicago (organizer). Exh. cat. with foreword by Lionello Venturi and text by Katherine Kuh.

The Walker Art Center, Minneapolis, *Expressionism 1900–1955*, January 22–March 11. Traveled to: The Institute of Contemporary Art, Boston, April 12–May 20; The San Francisco Museum of Art, June 6–July 22; The Cincinnati Art Museum and Contemporary Arts Center, August 28–September 23; The Baltimore Museum of Art, October 9–November 4; and The Albright Art Gallery, Buffalo, New York, November 16–December 30. Exh. cat. with foreword by H. H. Arnason and introduction by Sidney Simon. [Katzman's work was on view in the Walker Art Center venue only].

Whitney Museum of American Art, New York, *Annual Exhibition: Sculpture, Paintings, Watercolors, Drawings*, November 14, 1956–January 6, 1957. Exh. cat.

1957

The National Institute of Arts and Letters, New York, *An Exhibition of Works by Candidates for Grants in Art, 1957*, March 15–13. Exh. cat.

Whitney Museum of American Art, New York, *1957 Annual Exhibition: Sculpture, Paintings, Watercolors*, November 20, 1957–January 12, 1958. Exh. cat.

1958

The Alan Gallery, New York, *Important New Paintings and Sculpture by Herbert Katzman, William King, Jack Levine, Yutaka Ohashi, Nathan Oliveira, Charles Oscar, Easton Pribble, Robert Stanley, Rueben Tam and Others*, January 20–February 8.

• D[evree], H[oward]. "Lively Group Show at Alan Gallery." *The New York Times*, January 24.

The National Institute of Arts and Letters, New York, *An Exhibition of Works by Candidates for Grants in Art, 1958*, March 14–April 6. Exh. cat.

Rome–New York Art Foundation, Rome, *American Artists of Younger Reputation/Giovani Pittori Americani*, April 14–unknown closing date. Exh. cat. with text by James Johnson Sweeney.

The Brooklyn Museum, New York, *Brooklyn Bridge: 75th Anniversary Exhibition*, April 29–July 27. Exh. cat. with text by Mrs. Clarence G. Bachrach and poem by Hart Crane.

The American Academy of Arts and Letters and The National Institute of Arts and Letters, New York, *Exhibition of Work by Newly Elected Members and Recipients of Honors and Awards*, May 22–June 22. Exh. cat.

The Alan Gallery, New York, *Fifth Anniversary Exhibition: New Paintings and Sculpture*, September 8–27. Exh. brochure.

The Smithsonian Institution in cooperation with the Institute of International Education (organizer), *Fulbright Painters*, September 16–October 5. Venue: Whitney Museum of American Art, New York. Exh. cat. with foreword by Donald J. Shank and introduction by Lloyd Goodrich.
• C[ampbell], L[awrence]. "Fulbright Painters." *Art News* (New York) 57, no. 6 (October): pp. 13–14.

1959

Galleries, Architecture Building, College of Fine and Applied Arts, University of Illinois, Urbana, *Ninth Exhibition of Contemporary American Painting and Sculpture*, March 1–April 5. Exh. cat. with texts by Edwin C. Rae and Allen S. Weller.

1960

The Pennsylvania Academy of the Fine Arts, Philadelphia, *The One Hundred and Fifty-fifth Annual Exhibition: American Painting and Sculpture*, January 24–February 28. Exh. cat.

The Alan Gallery, New York, *Modern Paintings: Drawings, Sculpture, Collages. Katzman, King, Levine, Ohashi*, November 14–December 3. Exh. brochure.
• Preston, Stuart. "Art: Allusive Portraits." *The New York Times*, November 19.

1961

The Art Institute of Chicago, *64th American Exhibition: Painting and Sculpture*, January 6–February 5. Exh. cat. with foreword by J[ohn] M[axon].

Krannert Art Museum, College of Fine and Applied Arts, University of Illinois, Urbana, *Contemporary American Painting and Sculpture*, February 26–April 2. Exh. cat. with foreword by C. V. Donovan and texts by Thomas H. Garver and Allen S. Weller.

The Brooklyn Museum, New York, *The Nude in American Painting*, October 6–December 10. Exh. cat.

1962

Whitney Museum of American Art, New York, *Forty Artists Under Forty: From the Collection of the Whitney Museum of American Art*, July 23–September 16. Traveled to: Munson-Williams-Proctor Institute, Utica, New York, October 14–November 18; Rochester Memorial Art Gallery, New York, December 2–31; Roberson Memorial Center, Binghamton, New York, January 15–February 17, 1963; Albany Institute of History and Art, New York, March 3–31, 1963; Everson Museum of Art, Syracuse, New York, April 14–May 12, 1963; Andrew Dickson White Museum of Art, Cornell University, Ithaca, New York, May 26–June 23, 1963; and Albright-Knox Art Gallery, Buffalo, New York, 1963. Exh. cat. with texts by Lloyd Goodrich and biographical notes edited by Edward Bryant.

Hathorn Gallery, Skidmore College, Saratoga Springs, New York, *An Invitational Exhibition of Contemporary American Drawings*, November 28–December 15. Exh. cat.

1963

National Academy of Design, New York, *138th Annual Exhibition of Painting in Oil, Sculpture, Graphic Art, Watercolors*, February 21–March 17. Exh. cat. with introduction by Edgar I. Williams.

Krannert Art Museum, College of Fine and Applied Arts, University of Illinois, Urbana, *Eleventh Exhibition of Contemporary American Painting and Sculpture, 1963*, March 3–April 7. Exh. cat. with foreword by C. V. Donovan and text by Allen S. Weller.

1964

The Pennsylvania Academy of the Fine Arts, Philadelphia, *The One Hundred and Fifty-ninth Annual Exhibition of American Painting and Sculpture*, January 15–March 1. Exh. cat.

1967

The American Academy of Arts and Letters, New York, *Exhibition of Paintings Eligible for Purchase under the Childe Hassam Fund*, November 17, 1967–February 4, 1968. Exh. cat.

The Gallery of Modern Art, New York, *Dealers' Choice: An Exhibition at the Gallery of Modern Art, including the Huntington Hartford Collection*, December (exact dates unknown).

1968

Saint Paul Art Center, *Fourth Biennial Exhibition of Drawings USA '68*, dates unknown. Exh. cat.

1969

American Federation of Arts, New York (organizer), *The One Hundred and Sixty-fourth Annual Exhibition: Watercolors, Prints, Drawings*, January 17–March 2. Venue: The Pennsylvania Academy of the Fine Arts and The Philadelphia Water Color Club. Exh. cat.

American Federation of Arts at Graham Gallery, New York, *Institute of International Education: Artists Abroad*, September 16–October 5, 1969. Traveled to: Graham Gallery, New York, September 16–October 5, 1969; International Student Center, Los Angeles, January 15–February 25, 1970; Denver Art Museum, Colorado, March 1–29, 1970; Economics Lab. Inc., Osborn Building, St. Paul, Minnesota, April 12–May 4, 1970; The Arts Club of Chicago, May 24–June 28, 1970; National Collection of Fine Arts, Smithsonian Institute, Washington, D.C., July 23–September 9, 1970; Huntington National Bank, Columbus, Ohio, November 1–29, 1970; Miami Dade Junior College, Miami, Florida, August 22–September 19, 1971; Paul Sargent Gallery, Eastern Illinois University, Charlestown, October 10–November 7, 1971; and Canton Art Institute, Canton, Ohio, November 28–December 28, 1971. Exh. cat. with foreword by Kenneth Holland, introduction by John Gordon, and text by J. William Fulbright.

1971

Minnesota Museum of Art, Saint Paul, *Drawings in Saint Paul*, December 2, 1971–January 23, 1972. Exh. cat. with prologue by Malcolm Lein and text by A. Hyatt Mayor.

1972

The University Art Gallery, Heter Hall, University of Massachusetts Amherst, *1971: Art Acquisitions*, March 1–24. Exh. cat.

1975

The William Benton Museum of Art, The University of Connecticut, Storrs, *Drawings: Techniques and Types*, February 8–March 9. Exh. cat. with introduction by Frederick den Broeder and Stephanie Terenzio.

Whitney Museum of American Art, New York, *American Abstract Painting*, July 24–October 26.

The American Academy of Arts and Letters, New York, *Exhibition of Pictures Eligible for Hassam Fund Purchase*, November 10, 1975–January 4, 1976. Exh. cat.

Boston University Art Gallery, *The Portrait*, December 2–21.

1976

School of the Art Institute of Chicago, *Visions: Painting and Sculpture. Distinguished Alumni 1945 to the Present*, October 7–December 10. Exh. cat. with text by Dennis Adrian.

Lyman Auditorium, Southern Connecticut State College, New Haven, *Northeast Regional Invitational Drawing Exhibition*, November 1–20. Exh. cat. with introduction by Nicholas Orsini.

1977

The Weatherspoon Art Gallery, University of North Carolina, Greensboro, *Art on Paper*, November 13–December 18.

1978

The Indianapolis Museum of Art, *Painting and Sculpture Today 1978*, June 15–July 30. Exh. cat. edited and compiled by Hilary D. Bassett with text by Robert A. Yassin.

1979

The Art Institute of Chicago, *Alumni of the School of the Art Institute of Chicago Centennial Exhibition*, November 23, 1979–January 20, 1980. Exh. cat. with texts by Katherine Kuh and Norman L. Rice.
• Artner, Alan G. "Pleasures on View: Institute Marks End of Its Centennial." *Chicago Tribune*, December 2.

1980

Whitney Museum of American Art, New York, *The Figurative Tradition and the Whitney Museum of American Art: Paintings and Sculpture from the Permanent Collection*, June 25–September 28. Exh. cat. published in association with the University of Delaware Press, Newark, and Associated University Presses, London and Toronto; text by Patricia Hills and Roberta K. Tarbell.

1981

National Academy of Design, New York, *Recent Acquisitions 1979–1981: Gifts from Academicians and Associates of the National Academy of Design*, April 29–June 7. Exh. cat. with introduction by Mario Amaya.

Sordoni Art Gallery, Wilkes University, Wilkes-Barre, Pennsylvania, *A Range of Contemporary Drawing*, August 31–September 20.

1982

National Academy of Design, New York, *157th Annual Exhibition*, February 26–March 28. Exh. cat. with foreword by Robert S. Hutchins and introduction by John H. Dobkin.

1983
National Academy of Design, New York, *158th Annual Exhibition*, March 17–April 17. Exh. cat. with foreword by Robert S. Hutchins and introduction by John H. Dobkin.

1984
National Academy of Design, New York, *159th Annual Exhibition*, March 8–April 5. Exh. cat. with foreword by Robert S. Hutchins and introduction by John H. Dobkin.

The International Exhibitions Foundation, Washington, D.C. (organizer), *Twentieth-Century American Drawings: The Figure in Context*. Traveled to: Terra Museum of American Art, Evanston, Illinois, April 26–June 17; The Arkansas Arts Center, Little Rock, July 5–August 19; Oklahoma Museum of Art, Oklahoma City, September 1–October 15; Toledo Museum of Art, November 7–December 30; Elvehjem Museum of Art, Madison, Wisconsin, January 19–March 3, 1985; and National Academy of Design, New York, March 19–May 5. Exh. cat. with text by Paul Cummings.

1985
National Academy of Design, New York, *160th Annual Exhibition*, February 8–March 9. Exh. cat. with foreword by Robert S. Hutchins and introduction by John H. Dobkin.

1986
National Academy of Design, New York, *161st Annual Exhibition*, April 8–May 4. Exh. cat.

Denise Cadé Gallery, New York, *1950's American Artists in Paris, Part III*, November 4–December 15. Exh. cat. with introduction by Sidney Geist.

1987
National Academy of Design, New York, *162nd Annual Exhibition*, March 24–April 29.
• Smith, Roberta. "Group Exhibitions Show Off New Talent and Striking Styles." *The New York Times*, sec. C, April 24.

1994
Whitney Museum of American Art, New York, *A Year from the Collection, Circa 1952*, February 12–April 17. Exh. cat. with foreword by Adam D. Weinberg and texts by Karal Ann Marling and Beth Venn.
• Kimmelman, Michael. "Review/Art; At the Whitney, It's 1952 All Over Again." *The New York Times*, sec. C, February 18.

1997
Wagner College, Staten Island New York, *Drawings*, March (exact dates unknown).

The American Academy of Arts and Letters, New York, *Invitational Exhibition of Painting and Sculpture*, March 3–29. Exh. cat.

1998
National Museum of American Art, Smithsonian Institution, Washington, D.C. (organizer), *Modern American Realism: The Sara Roby Foundation Collection from the National Museum of American Art*. Traveled to: Cornell Fine Arts Museum, Rollins College, Winter Park, Florida, March 7–May 3; Madison Arts Center, Wisconsin, May 31–August 9; The Columbus Museum of Art, Columbus, Georgia, August 30–November 1; The Heckscher Museum of Art, Huntington, New York, November 21, 1998–January 31, 1999; Everson Museum of Art, Syracuse, New York, March 5–May 23, 1999; and Smithsonian Museum of American Art, September 24, 1999–January 3, 2000. Exh. cat. with introduction by Virginia M. Mecklenburg and text by William Kloss.

1999
National Academy of Design, New York, *174th Annual Exhibition*, March 17–April 25. Exh. cat. with foreword by Raoul Middleman and statement by Annette Blaugrund.

2000
National Academy of Design, New York, *175th Annual Exhibition*, February 9–March 26. Exh. cat. with foreword by Raoul Middleman, introduction by Annette Blaugrund, and text by Samuel F. B. Morse.

2001
National Academy of Design, New York, *176th Annual Exhibition*, May 22–June 24. Exh. cat. with forewords by Raoul Middleman and Gregory Amenoff and introduction by Annette Blaugrund.

2002
Studio 18 Gallery, New York, *Galerie Huit: American Artists in Paris 1950–52*, November 2–December 28. Exh. cat. with introduction by Sidney Geist and text by Geoffrey Jacques.

2003
National Academy of Design, New York, *178th Annual Exhibition*, May 2–June 15. Exh. cat. with foreword by Gregory Amenoff and introduction by Annette Blaugrund.
• Kramer, Hilton. "Remember Painting? You Can See Some Up on 89th Street." *The New York Observer*, May 12.

2009
Hutchins Gallery, C. W. Post Campus, Long Island University, Brookville, New York, *Different at Every Turn: Contemporary Painters of the Hudson River*, February 4–March 31. Traveled to: Art Gallery, Arts and Sciences Building, Kingsborough Community College, City University of New York, Brooklyn, April 8–28; Lake Champlain Maritime Museum, Vergennes, Vermont, May 23–June 28; Albany Institute of History and Art, New York, July 3–August 23; Gibson Gallery, State University of New York, Potsdam, September 11–October 17; and United States Military Academy at West Point, New York, October 29–January 10, 2010. Exh. cat.

PUBLIC COLLECTIONS

The Art Institute of Chicago

The Butler Institute of American Art, Youngstown, Ohio

Crocker Art Museum, Sacramento

Frederick R. Weisman Art Museum, University of Minnesota, Minneapolis

Herbert F. Johnson Museum of Art, Cornell University, Ithaca, New York

Hirshhorn Museum and Sculpture Garden, Washington, D.C.

The Museum of Modern Art, New York

National Academy Museum, New York

Neuberger Museum of Art, Purchase College, State University of New York, Purchase, New York

Palmer Museum of Art of The Pennsylvania State University, University Park

Richard F. Brush Art Gallery, St. Lawrence University, Canton, New York

Robert and Elaine Stein Galleries, Wright State University, Dayton, Ohio

Smith College Museum of Art, Northampton, Massachusetts

Smithsonian American Art Museum, Washington, D.C.

University Gallery, University of Massachusetts Amherst

Whitney Museum of American Art, New York

Yale University Art Gallery, New Haven, Connecticut

ABOUT THE
MUSEUM OF THE CITY
OF NEW YORK

The Museum of the City of New York celebrates and interprets the city, educating the public about its distinctive character, especially its heritage of diversity, opportunity, and perpetual transformation. Founded in 1923 as a private, non-profit corporation, the Museum connects the past, present, and future of New York City. It serves the people of New York and visitors from around the world through exhibitions, school and public programs, publications, and collections.